IMAGES
of America

CATHOLICS IN
WASHINGTON, DC

IMAGES
of America

CATHOLICS IN
WASHINGTON, DC

Christina Cox

ARCADIA
PUBLISHING

Published by Arcadia Publishing
Charleston, South Carolina

Printed in the United States of America

Library of Congress Control Number: 2013943020

For all general information, please contact Arcadia Publishing:
Telephone 843-853-2070
Fax 843-853-0044
E-mail sales@arcadiapublishing.com
For customer service and orders:
Toll-Free 1-888-313-2665

Visit us on the Internet at www.arcadiapublishing.com

*To the Blessed Virgin Mary, her son Jesus Christ, and for John,
Dorothy, Patrick, and the Cox family, who have always supported me*

CONTENTS

ACKNOWLEDGMENTS

Catholics in Washington, DC would not have been possible without the assistance of the many priests, sisters, photographers, archivists, historians, church pastors, secretaries, and librarians who supported our book project.

With much gratitude, the author would like to thank the following people for their involvement in image gathering and for access to the archival collections of their affiliate institutions:

Rev. Msgr. W. Ronald Jameson, VF, and Dick Schmidt of the Cathedral of St. Matthew the Apostle (CSMA);

Sr. Mary Hayes PhD, SND, and Jason Pier of Trinity Washington University (TWU);

Lynn Conway, Ann Galloway, and David Hagen of Georgetown University (GU);

Jane Stoeffler and Paul Kelly at the American Catholic History Research Center at CUA Archives (CUA is Catholic University of America);

Marianne Giltrud, BS, MSLS, and Stephen Connaghan of the Mullen Library at CUA;

Very Reverend Phillip J. Brown, PSS, JCD, and Donna Leo of Theological College of the National Seminary of CUA;

Karen Levenback, PhD, MSLS, and Fr. Larry Dunham, OFM, of the Franciscan Monastery of the Holy Land (FM);

Taylor Henry of the Archdiocese for the Military Services, USA (AMSUSA);

Fred Maroon, photographer Suzy Maroon, and Marc Maroon;

Peter Stepanek of Sky High Art Media;

Msgr. Salvatore Criscuolo of St. Patrick's Catholic Church and Marie Valcourt;

Dena Grant of St. Augustine Church and the Library of Congress (LOC);

John F. Kennedy Presidential Library and Museum (JFKLM), Mary Rose Grossman, and Kora Welsh;

Msgr. Robert Trisco of Catholic Historical Society;

Fr. Klaus Sirianni and Elsa Thompson of St. Stephen Martyr Church;

Mark Zimmerman, *Catholic Standard* editor, and especially photojournalist Michael Hoyt;

Stefani Manowski and Fr. John Lynch, CSP, of St. Paul's College;

Marianne Worley of MedStar Georgetown University Hospital Public Relations and Hunter Hardinger;

Fr. Alfred Harris, SJ, of St. Mary's Mother of God Church, and Soraya Strobach, parish secretary.

The National Museum of Catholic Art and Library collection (NMCAL) includes photographs taken by the author.

A thank-you goes to James Pinkelman, Ann Fitzgerald, Grand Knight James Ryan, Knights of Columbus, St. Joseph the Worker Council 14516, and Emilio Sanchez for the donations toward purchase of the photographs. Thanks also go to singer Anthony Kearns and Kirsten Fedewa Consultants LLC for their photographs.

A thank-you is extended to all the people at Arcadia Publishing who helped organize, print, and market the book.

INTRODUCTION

Catholics in Washington, DC is a lively pictorial history of events, places, and people who have promoted Catholicism in our nation's capital. The faithful men and women who became the first American Catholics are the inspiration and motivation for this book. While researching for a Catholic historical exhibition for our museum, we discovered hundreds of vintage images of Catholic churches, convents, universities, rectories, missionary groups, religious orders, early parochial buildings, hospitals, schools, and the fascinating people who were carving their dreams in America's history. These enriched archives and libraries were a treasure trove of facts, drawings, maps, books, and old photographs of the many Catholic communities of Washington, DC.

Leonard Calvert, second Baron Baltimore, led the *Ark* and *Dove* ships with 300 settlers to sail to America. The *Ark* landed on St. Clement's Island on March 25, 1634. Father Andrew White, an English Jesuit, and other priests accompanied Calvert and celebrated the first mass to thank God for their safe landing. Father White wanted the Jesuits to establish a Catholic mission in the Maryland colony. White thought he could convert the American Indians to the Catholic faith. Before 1776 and the American Revolution, Catholics in the 13 colonies were part of the ecclesiastical jurisdiction of the bishop of the Apostolic Vicariate of the London District in England. Catholics were persecuted in Maryland and Virginia. Religious freedom was not possible, and many Catholics worshiped during masses said in private chapels in the homes of the wealthy residents. Only a few Jesuit priests rode on horseback to perform holy mass on private properties because this practice was illegal, and if caught, it would mean death or imprisonment.

The Jesuits were the first to establish churches in Baltimore, Maryland, and Washington, DC, through the bravery of Fr. John Carroll, SJ. As the population grew, more Catholics came and early churches were developed: missionaries, schools, and colleges began their ministries. Early churches like Holy Trinity in Georgetown, St. Patrick's, St. Matthew the Apostle, St. Augustine's, St. Mary's, Mother of God, and St. Stephen Martyr were downtown. St. Joseph's and St. Peter's Churches were built in the southeast on what later became known as Capitol Hill near the Navy yard. Others were all constructed after 1790 and continued to be built until 1878 for serving different groups, Irish, German, and African American neighborhoods. In 1846, founding Bishop Thomas Shahan began his dream, to construct a building to be dedicated under the protection of Mary Immaculate as the patroness of the United States. This would be the Basilica of the National Shrine of the Immaculate Conception. In 1898, Fr. Godfrey Schilling, OFM, completed his vision to extend the Franciscans' work to the United States. Fr. Isaac Hecker came and began educating priests after the Civil War. The Visitations Sisters, Sisters of Charity, Daughters of Charity, Sisters of St. Joseph, Oblates Sisters, and the Sisters of Notre Dame de Namur all tried to educate women and children, help the poor, and run orphan houses. After the Civil War, there were no hospitals or decent health care facilities, and the nuns and sisters took over this role, working in hospitals such as Georgetown University's. During the Civil War, Catholics fought against slavery, and over 300,000 enlisted or were drafted by the Union. Catholic parishes and schools were set up to act as hospitals, and nuns attended to the wounded. Sisters of Charity who were in charge of St. Vincent Orphanage were asked to take charge of the Providence Hospital in

1861. In the early 1900s, the Sisters of Charity, Sisters of the Daughters of Mercy, and the Sisters of St. Francis helped educate women to be nurses and established training programs.

The first early institutions started in the mid-1850s, through a large immigration of Irish and Germans. The Catholic identity began to flourish as they built their own churches, schools, and cemeteries. In neighborhoods near Georgetown was Holy Trinity, near the Potomac River; downtown was St. Patrick's Church; St. Augustine's stood near the White House; and to the southeast was St. Peter's, near the Capitol. Several Catholic colleges and universities were founded: Georgetown University in 1789, Catholic University of America in 1887, and Trinity College for women in 1897.

Archbishop Michael Curley was the 10th archbishop of Baltimore and the first archbishop of Washington. Curley opened 66 schools in 18 years, established the diocesan offices for Catholic Charities in 1923, and was a strong opponent of Pres. Franklin Roosevelt's foreign policy. On July 22, 1939, Pope Pius XII separated the diocese of Washington, DC, from Baltimore, Maryland. It then became become the separate Archdiocese of Washington; at that time, St. Matthew's was made a cathedral and mother church of the new archdiocese. In 1948, Archbishop Patrick O'Boyle was installed as the first resident archbishop of Washington and recognized for his racial equality and support of organized labor. In 1973, Pope Paul VI appointed William Cardinal Baum as archbishop of Washington, and he hosted the visit of the newly elected Pope John Paul II in 1979. Pope John Paul II later consecrated James Cardinal Hickey after the retirement of Cardinal Baum in 1980. Cardinal Hickey, who had served the poor, established the Gift of Peace Convent with Mother Teresa and the Missionaries of Charity for the homeless and terminally ill. Theodore Cardinal McCarrick became archbishop of Washington under Pope John Paul II in 2001 and was known for his multicultural and social service with special focus on the Hispanic community. In 2006, Donald Cardinal Wuerl was appointed archbishop of Washington. Wuerl hosted Pope Benedict XVI's official Washington tour in 2008. The pope's meetings included Pres. George W Bush, the National Park Service, Pope John Paul II Cultural Center, the Basilica of the National Shrine of the Immaculate Conception, Catholic University of America, and the embassy of the Holy See. Cardinal Wuerl is known for his teaching ministry and has written a dozen books on the Roman Catholic Church. The Apostolic Nunciature was established as a delegation to the United States on January 24, 1893; the Holy See established communications under Pope Leo XII and Pres. Benjamin Harrison.

Catholic women of faith came at the request of Archbishop John Carroll to start schools and orphanages for the children. Sr. Elizabeth Seton and Mother Teresa Lalor from Ireland formed the Visitation School. It is one of the oldest monasteries of the Order of the Visitation in the United States. The new religious orders made immense contributions to our country's education, helping the poor and opening their doors to all ages. There were segregated schools that had different classrooms for privileged children. Orphanages were set up for children whose parents died of disease or from the Civil War. Mother Elizabeth Seton and the Sisters of Charity were one of the first orders opening schools and educating children. During the Civil War, the Sisters of Mercy opened a city hospital with $6,000 secured from Congress by Drs. Toner and Young. In 1903, Providence Hospital was funded by Congress and founded by the Daughters of Charity of St. Vincent de Paul. The good sisters took on the role of nursing the poor, the sick, and the outcasts. On the other end of town in the early 1900s, Georgetown University nurses began to train, and a new hospital was started in Georgetown.

Many Catholic women came to Washington to help the poor, sick, and homeless. Dorothy Day, founder of the Catholic Worker Movement, came to Washington; she was known for feeding the homeless in her soup kitchens. Mother Teresa of Calcutta took a stand for the right to life and human dignity. The Missionaries of Charity Sisters formed a convent and residential home called a Gift of Peace. As a Noble Prize winner, Mother Teresa spoke at the National Prayer Breakfast. Women and men marched for the right to life after *Roe v. Wade* made a change in the law. Nellie Gray, a convert to Catholicism, made headlines in front of the Capitol when defending the rights of the unborn as a pro-life activist. The Kennedy women, including Rose,

Jackie, Ethel, Jean, and Eunice, gave great services to our country and the Catholic Church. They advocated in politics, mental health care, and Catholic Charities. Princess Grace of Monaco gave a poetry reading at Catholic University of America and later had formal invitation, along with her husband, Prince Rainier, to visit the White House as guests of Pres. John F. Kennedy and First Lady Jacqueline Kennedy.

In 1924, Alfred E. Smith, a Roman Catholic and governor of New York, was proposed as the Democratic Party's presidential nominee, but he was defeated at the convention. In 1928, Pres. Franklin D. Roosevelt nominated Smith at the next Democratic convention, but Smith lost to Herbert Hoover. In America, there was anti-Catholic sentiment, and there had never been a Roman Catholic elected to the highest office. With a strong influence in the South, the Ku Klux Klan and the Protestants spread stories. They suggested Al Smith would install the pope in the White House and force Protestant children to attend Catholic schools. This all led to defeat for Smith in the South. It was not until 32 years later, on January 2, 1960, that Massachusetts senator John F. Kennedy announced he would run for the president of the United States.

John Fitzgerald Kennedy was the son of businessman Joseph P. Kennedy and socialite Rose Fitzgerald Kennedy. Rose's father, John Fitzgerald, known as "Honey Fritz," was the mayor of Boston, Massachusetts. The Kennedys were a large Irish Catholic family; many of them served in World War II, entered politics, and helped Catholic Charities. In 1943, their second son, John F. Kennedy, entered World War II as a US Navy lieutenant on *PT-109*. When his boat was destroyed, he helped rescue his fellow soldiers and became a Navy war hero. In 1946, he ran for the 11th Congressional district in Massachusetts. Kennedy won and became a congressman for six years; during that time, he was lived in Georgetown and worked on Capitol Hill. In 1952, Kennedy had political power, ambition, and good looks.

Kennedy went on to run for US senator from Massachusetts. In 1952, Kennedy first met the beautiful Jacqueline Bouvier, a *Washington Times-Herald* photojournalist, at a friend's dinner party in Georgetown. They fell in love and had a beautiful Roman Catholic wedding in Rhode Island in 1953. They continued to live in Georgetown as young newlyweds. He wrote *Profiles in Courage* and won a Pulitzer Prize for a biography in 1957. In 1960, John F. Kennedy was elected the 35th president of the United States and was the first Catholic ever to achieve that role. We collected historical photographs of President Kennedy going to mass, upholding Catholic traditions, and speaking at Catholic universities in Washington, DC. Kennedy visited Pope Paul VI at the Vatican on July 2, 1963, just several months before his death. On November 22, 1963, President Kennedy was assassinated in Dallas, Texas, and the country mourned this wonderful president. His state funeral was watched on television by millions of people around the world. On Monday, November 25, 1963, the state funeral mass of President John F. Kennedy was held at the Cathedral of St. Matthew the Apostle, who is the patron saint of civil servants. Kennedy is the first and only Roman Catholic at the time of this writing to have been president of the United States.

In 1888, the Catholic Church exercised a prominent role in shaping America's labor movement. James Cardinal Gibbons's Knights of Labor and later labor leaders have often been Catholic: Secretary of Labor James P. Mitchell, John Sweeney, Edward Malloy, Richard Trumka, Edward Smith of Union Labor Life Insurance Company (Ulicco), and John Bauers of the International Longshoremen Association (ILA) all gave back to Catholic Charities.

In 1968, Pres. Lyndon Johnson began adding representatives to the seat of the Holy See in Vatican City. Our appointed ambassadors to the Holy See over the years were Frank Shakespeare, Thomas Melady, Raymond Flynn, James Nicholson, Lindy Boggs, Francis Rooney, Mary Anne Glendon, Miguel Diaz, and Kenneth Hackett. Catholics were appointed to sit on the Supreme Court, including Justices Antonin Scalia and Clarence Thomas, and others were elected to positions in Congress. FBI director Louis Freeh was a Catholic supporter and attended the Red Mass by the John Carroll Society chaplain Msgr. Peter Vaghi. Since the 1973 *Roe v. Wade* decision legalized abortion, there has been a rally called the March for Life for the pro-life community on Catholic Hill. Each January brings thousands, no matter what the weather, to come fight for the unborn. There are many Catholic foreign ambassadors, military leaders, and members

of Congress we have discovered who have been brought up with Catholic educations and are working in the Capitol.

Through television and later the Internet, we have witnessed the papal pilgrimages to Washington, DC, over the last three to four decades. In 1979, Pope John Paul II was the first pope to visit to the White House. Pres. Jimmy Carter and First Lady Rosalynn Carter warmly greeted His Holiness in the Oval Office. The president and the pope spoke about the world not as diplomats but as two Christian brothers. The pontiff also toured Catholic University of America and the Cathedral of St. Matthew the Apostle and held an open public mass on the National Mall. This outstanding Polish pope later formed a so-called holy alliance with Pres. Ronald Reagan to help dissolve the communist empire in Eastern Europe. In His Holiness's lifetime, he also met with Pres. George H.W. Bush, Pres. Bill Clinton, and Pres. George W. Bush at Vatican City. On April 27, 2014, two famous pontiffs were canonized—Pope John Paul II, also known as John Paul the Great, and Pope John XXIII, known as "The Good Pope," in Vatican City.

In 2008, Donald Cardinal Wuerl welcomed Pope Benedict XVI on the apostolic visit and drew crowds of millions at papal mass at the new Nationals Park in Washington, DC. His Holiness toured the Basilica of the National Shrine of the Immaculate Conception and the Pope John Paul II Shrine. In February 2013, we learned of the surprise announcement and resignation of Pope Benedict XVI, and we happily welcomed new pontiff Jorge Cardinal Bergoglio from Buenos Aries, Argentina. His Holiness chose the name Pope Francis after a Franciscan priest, St. Francis of Assisi. He is the first pontiff from the Americas and was formally of the Jesuit order. In 2015, Pope Francis plans a formal visit to Philadelphia, Pennsylvania, on September 27. Invited by the Philadelphian archbishop Charles Cardinal Chaput, OFM, escorted by the Most Reverend Vincenzo Paglia, president of the Pontifical Council of Families, and hosted by the delegation of World Meeting of Families, Pope Francis will be making his first public visit to the United States.

In conclusion, the pride of the District of Columbia is our history, and our international tourism grows. We should explore the roles of faithful Catholics. This book clearly reflects the faith of many devout Christians who through broke through boundaries and barriers and are the true heroes of Washington today.

One

EARLY CATHOLIC INSTITUTIONS

In 1789, Fr. John Carroll, the first bishop of the Catholic Hierarchy of the United States, purchased a piece of land for a new Jesuit institution called Georgetown Academy. Erected in 1792, the first building on the campus, a colonial structure with 11 classrooms, was named Old South. It was high on a hill with a wonderful view of the Potomac River. Today, Georgetown University (GU) is the nation's oldest Catholic university. (LOC.)

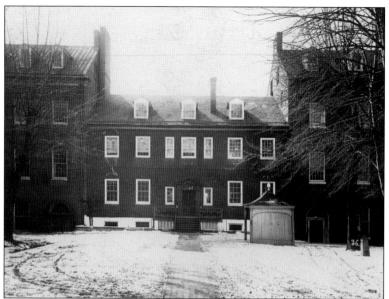

Pictured here is the South Building before it was demolished in 1904 to make way for Ryan Hall. The 69th Regiment of the Fighting Irish of New York used it the during the Civil War. In 1862, several campus buildings were requisitioned for hospitals. Pres. Abraham Lincoln visited the campus in May 1861 to review Union troops. (GU.)

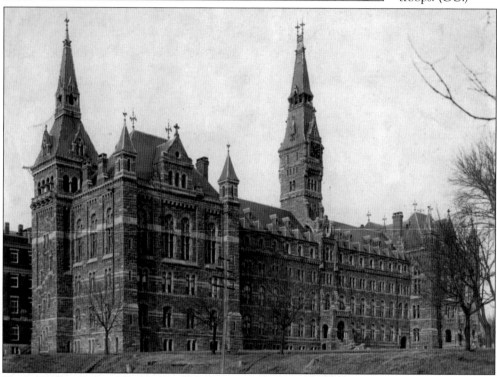

Healy Hall was erected in 1877–1879 but not completed until after 1900. The building was named after Rev. Patrick Healy, SJ, Georgetown's president at the time of its initial construction and the first African American head of a predominantly white major university, who oversaw significant expansion at the school. This High Victorian Gothic campus building is a National Historic Landmark. It was built with bluestone from the Potomac Stone Company quarries and is truly a wonderful symbol of grandeur for the university today. John Smithmeyer and Paul Pelz were the architects. (GU.)

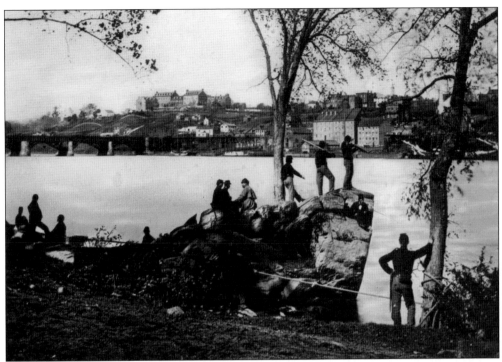

Union picket guards stand on Mason Island, now Theodore Roosevelt Island. Georgetown University is visible across the river. The Aqueduct Bridge spans the river near where Key Bridge now stands. This 1865 photograph is of the Union lookout points manned to protect the city from Confederate soldiers. (LOC.)

In 1797, North Building was completed to fill the need of an increasing enrollment, as more classrooms and housing were needed on campus. In 1809, Fr. William Matthews, Georgetown College president, received $400 to help finish the interior. Concerned over the appearance of the campus, he went to work on the building next to the plasterer, mixing mortar at his side to help finish the job. (GU.)

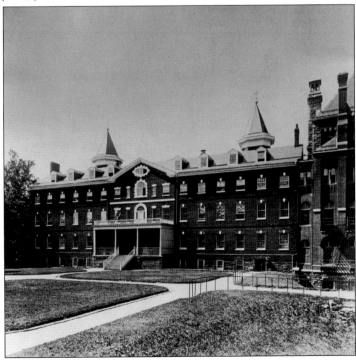

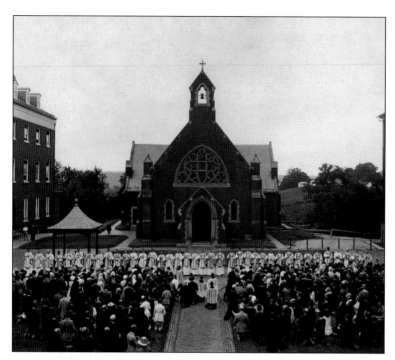

In 1925, newly ordained Jesuit priests receive a blessing in front of Dahlgren Chapel. This historic site is home to many traditions at Georgetown University, founded by Bishop John Carroll. The Jesuits' focus on liberal studies and religious principals has helped mold the university's identity. This wonderful chapel still holds wedding ceremonies, reconciliations, and baptisms. (GU.)

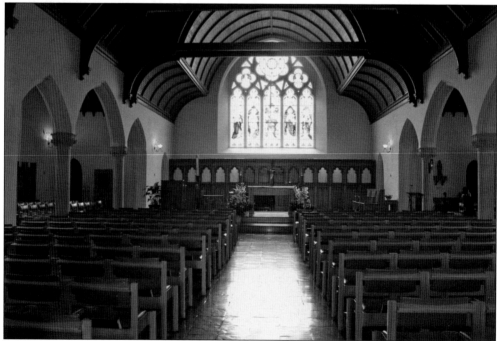

In 1893, the Dahlgren Chapel of the Sacred Heart was a gift from Elizabeth Drexel Dahlgren in memory of her infant son Joseph Drexel Dahlgren, who died in 1893. With 350 seats, the interior of the chapel is a GU landmark, with stained-glass windows, a beautiful altar, an old confession booth, and oak pews. Mass is held daily at 12:00 p.m. (GU.)

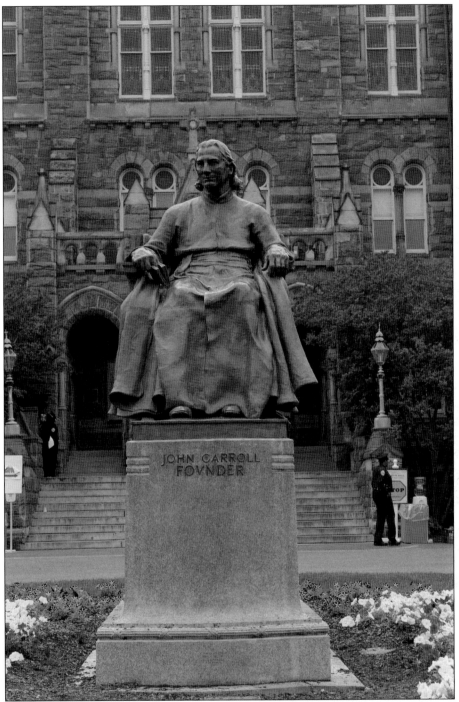

This bronze statue in front of Healy Hall is dedicated to Archbishop John Carroll, founder of Georgetown Academy. It was created by Irish sculptor Jerome Connor, who had been trained as a stone carver, and unveiled on May 4, 1912. The bishop is seated in a chair with a book in his right hand, wearing a church robe indicating his role as an archbishop. Connor was also commissioned to sculpt Robert Emmet, an Irish patriot, whose statue is near the White House. (NMCAL.)

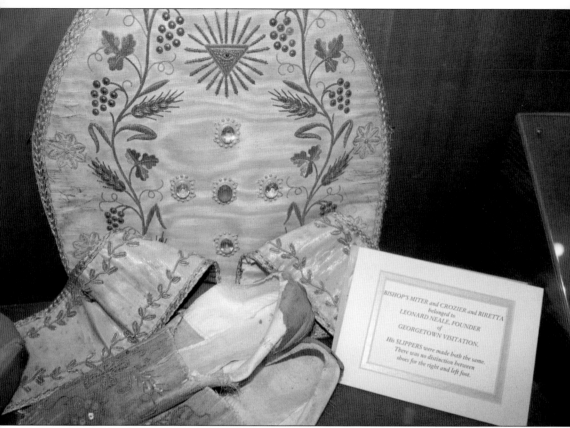

On display in the entry hall of the Georgetown Visitation Preparatory School is an exhibit case with the pontifical vestments of Archbishop Leonard Neale, SJ, one of the founders. The bishop's sacred garments are a white embroidered miter, biretta, and slippers. As a Georgetown resident and fourth president of Georgetown College, Neale, a Jesuit priest, was a friend of Archbishop John Carroll and Pres. George Washington. Neale succeeded Archbishop Carroll as the second archbishop of Baltimore, Maryland, on December 3, 1815. It is known that Fr. Leonard Neale was called to Mount Vernon and the bedside of the dying George Washington just four hours before he passed on December 14, 1799. Georgetown Visitation is among the oldest girls' schools on the East Coast. It has flourished for 200 years and is located near Georgetown University at 154 Thirty-fifth Street NW. (NMCAL.)

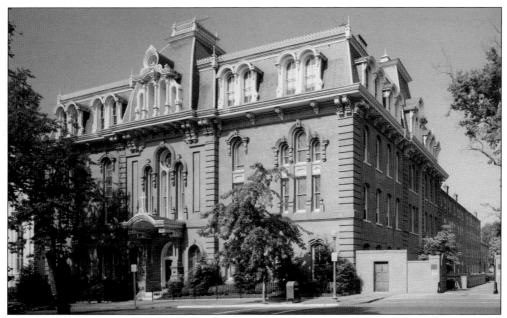

In 1799, Georgetown Visitation School was founded by the Order of Sisters of the Visitation. Fr. Leonard Neale, the archbishop of Baltimore, invited "three pious ladies to be founders [of] a school for young women and the Visitation monastery." Teresa Lalor and widows Maria McDermott and Maria Sharpe came to teach. Rooted in the Roman Catholic faith, Salesian tradition, and the Order of the Visitation, they committed to educate young women from diverse backgrounds. (LOC.)

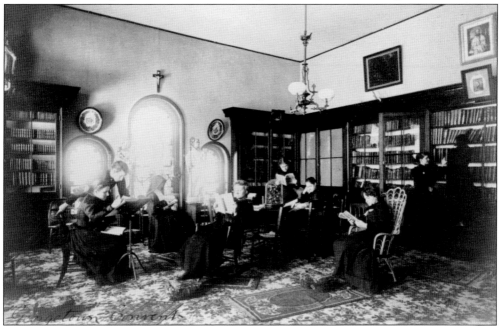

In the 1890s, well-dressed young women are studying in the Georgetown Visitation School reading room. These women were from well-to-do families and were taught reading, needlework, music, art, and French. On Saturdays, the school would educate slaves when it was illegal for a slave to learn to read or write. (LOC.)

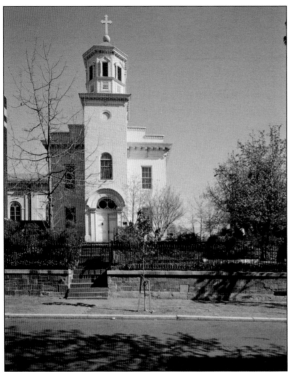

Holy Trinity is the oldest Catholic church still in operation in the District of Columbia. Slaves and presidents have been among the parishioners. In 1794, Fr. Francis Neale, SJ, brother of Archbishop Leonard Neale, operated the first chapel building. It was open to slaves, and Sunday pews were rented to the more affluent to help with the church's operations. In 1862, it was used as a Civil War military hospital. (LOC.)

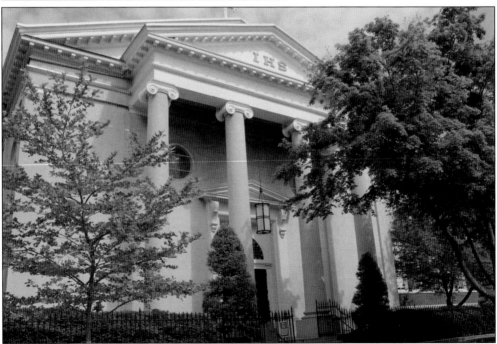

The second Holy Trinity Church was built in 1849 to accommodate the growing Catholic population. Wealthy families paid a fee to have placement in the front pews of the church. Slaves had to sit in the back of the pews or in the second balcony. Today, the church serves 3,500 residents of Georgetown and many Georgetown University students. (NMCAL.)

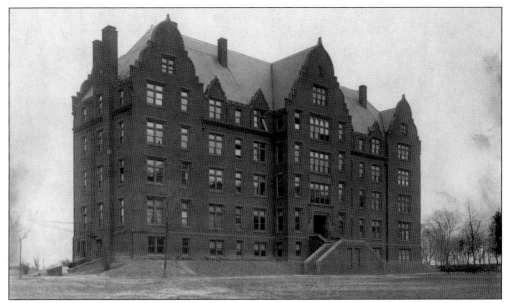

Keane Hall was the first dormitory for lay students on the campus of Catholic University of America (CUA). Pictured here, it was the first campus building to be seen from Michigan Avenue. In 1896, Keane Hall was built and named after Bishop John Keane, the first rector of the university (1839–1918). The building was renamed for Capt. Albert Ryan of Norfolk, Virginia, and demolished in 1970. (CUA.)

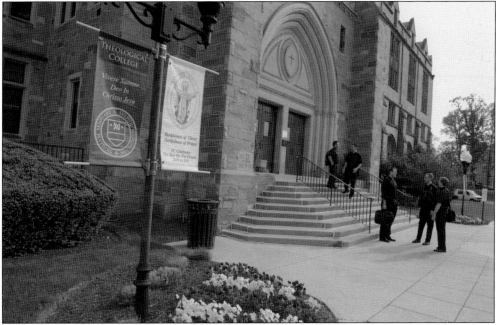

This photograph of young seminarians was taken at the entrance of the Theological College. It is a national Roman Catholic diocesan seminary and affiliated with Catholic University of America. It was founded by the Society of Saint Sulpice and originally operated with St. Mary's Seminary in Baltimore, Maryland, until 1924. Since 1940, the college has been a National Pontifical Seminary and promotes pastoral formation as a program for the priesthood. (Theological College.)

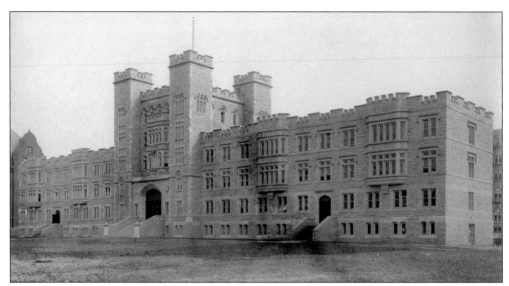

In 1911, Gibbons Hall was dedicated and named after James Cardinal Gibbons, archbishop of Baltimore (1877–1921). Gibbons was as one of the strongest advocates for the creation of Catholic University of America. The hall is now used as a female dormitory for 138 upperclassmen and regarded as one of the most historical and beautiful Gothic Revival buildings on the university's campus. (CUA.)

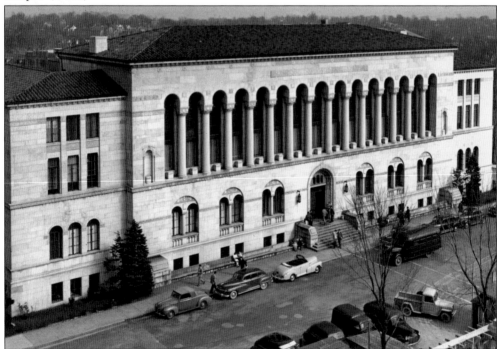

One of the best university libraries in Washington, DC, is the John K. Mullen of Denver Memorial Library at Catholic University of America. Mullen, an Irish Catholic from Denver, Colorado, pledged $500,000 for the library's construction, and it opened in September 1928. This library houses one of the best rare and special collections as well as the American Catholic History Research Center and university archives. (CUA.)

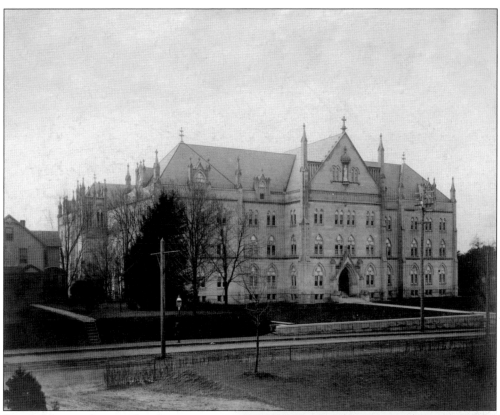

Pictured here is the completed Dominican House of Studies, formed with the help of James Cardinal Gibbons in the early 1900s. The community of Dominican friars is dedicated to preaching, prayer, and study. Inside is the Province of St. Joseph in the Order of Preachers, dedicated to the theological formation of Dominican friars and their service to the church. They are located on Michigan Avenue across from CUA. (CUA.)

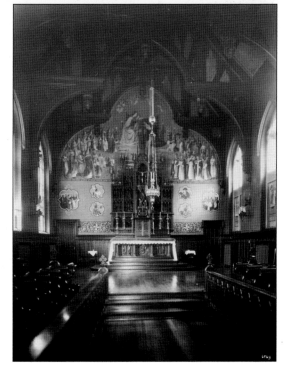

This is the interior of the private Dominican chapel at the Dominican House of Studies in 1907. In 1910, Adolph Tassan painted a large 25-by-15-foot religious mural. It depicts the story of the Virgin holding baby Jesus and giving a rosary to St. Dominic. The masterpiece also depicts the Dominican fathers, saints, and martyrs. The exquisitely carved altar exhibits the story of the rosary. (CUA.)

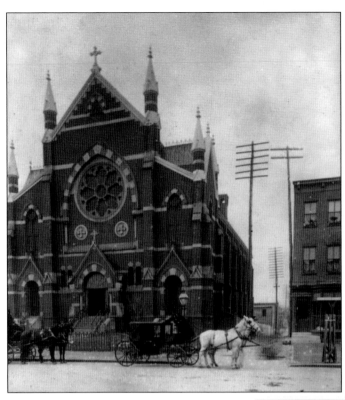

In 1858, St. Augustine's Catholic Church was established for the African American congregation and started its own choir. It was located at Fifteenth and M Street until 1946, when the Archdiocese of Washington, DC, sold the property to the Washington Post Company. It is the mother church of African American Catholics and the oldest black church in the capital, founded by freed slaves. These men and women established a Catholic school, rectory, and new chapel on Fifteenth Street under the patronage of St. Martin de Porres. (Left, LOC; below, NMCAL.)

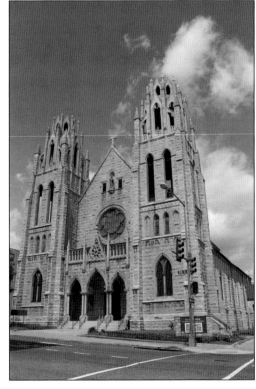

Old St. Matthew's Church was one of the mother churches in Washington, located a few blocks from the White House. In 1847, Fr. Charles White started a segregated school and old-age home for African Americans. Old St. Matthew's was replaced by the newer Cathedral of St. Matthew the Apostle on Rhode Island Avenue, completed in 1947. (LOC.)

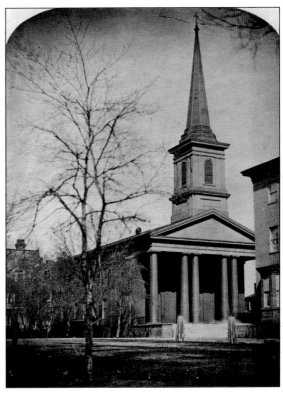

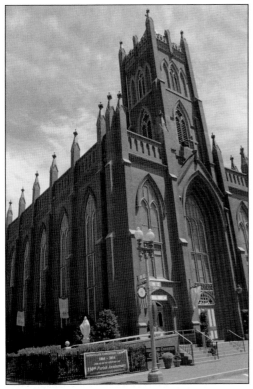

Pictured here is the Immaculate Conception Church. It was quickly established after the growth St. Patrick's and the Irish community experienced by 1864. Its beautiful bell tower was completed in 1900. The church school, rectory, and convent are in the National Register of Historic Places. The congregation just completed an interior renovation, and the church serves many local families, especially the African American community. (NMCAL.)

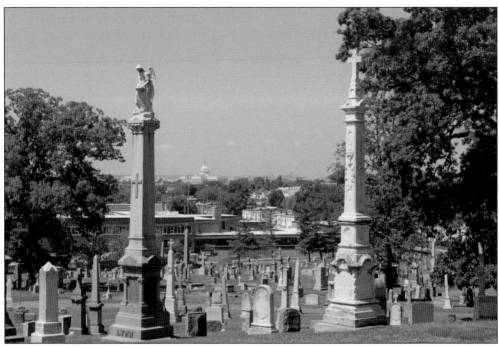

During the Civil War, church cemeteries were overcrowded, and the city's population was growing. In 1858, with permission from the archbishop of Baltimore, Fr. Charles White asked to establish a Catholic burial ground called Mount Olivet Cemetery. It became a historical place, with Civil War figures Mary Surratt and Confederate captain Henry Wirz; James Hoban, Irish-born architect who designed the White House; Daniel Carroll of Duddington, patriot, landowner, and Washington's first bank president; Capt. Thomas Carberry, the sixth mayor of Washington; many Congressmen; and war heroes buried there. Many Roman Catholic clergy are buried there, as well as nuns, brothers, priests, and orphan children from Providence Hospital. Mount Olivet was racially integrated, and the Catholic Church has always cared for those who grieve while honoring their dead. The cemetery holds 106,000 graves and consists of 85 acres of well-manicured lawns, hills, and trees. (Both, NMCAL.)

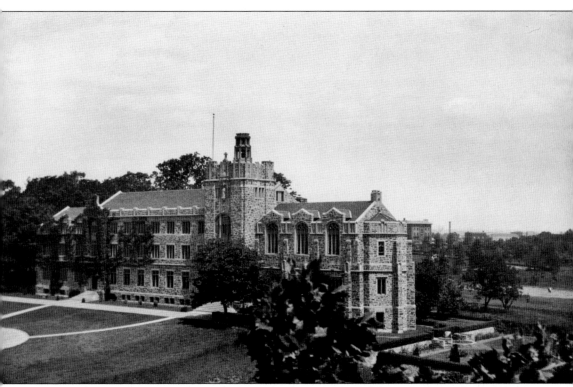

The Paulist Fathers began in July 1858 when four former Redemptorist missionaries formed a new religious movement around the vision of founder Fr. Isaac Thomas Hecker. The four Redemptorists were Isaac Hecker, Augustine Hewit, George Deshon, and Francis Baker. Father Hecker took a special interest in converting Protestants by introducing them to the Roman Catholic teachings. In 1914, St. Paul's College established a house of studies for the seminarians in Washington. After the Civil War, some 60 men and boys entered the Paulist's formation, stayed, and became priests. The college serves as a home for the Paulist priests who serve the local and national Catholic Church through a variety of apostolates, including education, evangelization, ecumenism, and mass communication. (St. Paul's College.)

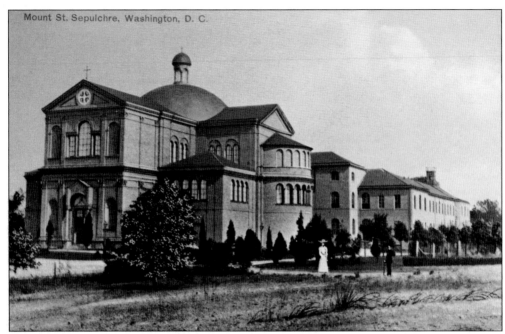

Mount St. Sepulchre, Washington, D. C.

The Very Reverend Charles Vassani established the US Commissariat of the Holy Land and planned to build a Holy Land in America and a Holy Sepulchre in Washington with Fr. Godrey Schilling, OFM. Called the Mount St. Sepulchre Franciscan Monastery (1898–1899), it is dedicated to St. Francis and the work of the friars guarding the Holy Land. The edifice was designed by Aristide Leonari, and the floor plan resembles a Jerusalem cross. It was built in the Neo-Byzantine style, and its layout is similar to the Hagia Sophia in Istanbul, Turkey. Attached to the church is a Neo-Romanesque monastery. This is an old postcard of the monastery located at 1400 Quincy Street NE, maintained by the friars. Below is the main altar with the fabulous Dome of the Baldachin designed by the Rambusch brothers. (Both, FM.)

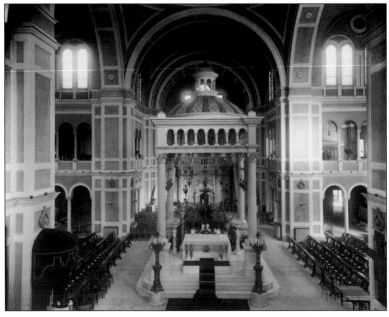

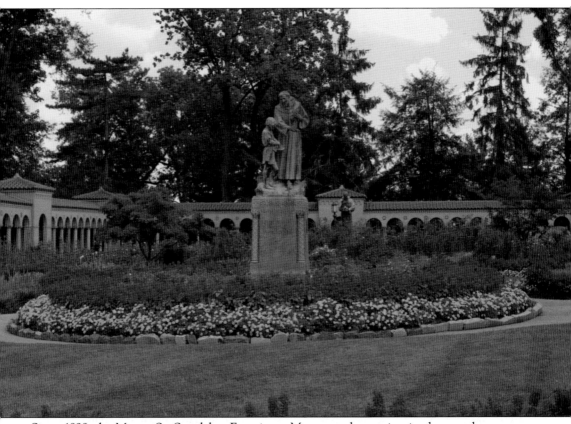

Since 1899, the Mount St. Sepulchre Franciscan Monastery has maintained an outdoor upper gardens sanctuary and rosary portico surrounding a bronze statue, *St. Francis and the Turtledoves.* This sculpture is the work of Porfirio Rosignoli from Florence, Italy, and was installed in the piazza in 1916. The garden, loaded with tulips and rose bushes and featuring a grotto dedicated to the Virgin Mary, is pictured here at the front entrance of the Franciscan monastery, in front of the church. The rosary portico with its 15 mosaics displaying the Mysteries of the Rosary was dedicated as a historic site in 1994. There is a Portiuncula Chapel (St. Mary of the Angels) in the gardens. It is a reproduction of a fourth-century church built in Assisi, Italy. The chapel was restored by St. Francis and venerated as the cradle and mother church of the order. (NMCAL.)

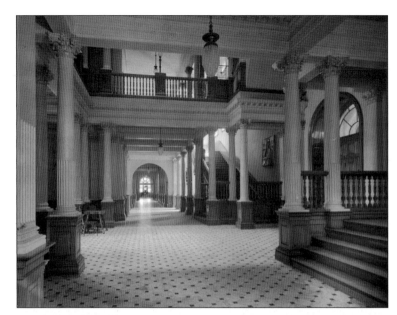

This is a view of the interior of Main Hall at Trinity College, built in 1909. The wide, formal staircases, marble floors, high ceilings, and oak beams evoke the elegance and sophistication of the college's identity. The hall was a place to gather before and after classes. (TWU.)

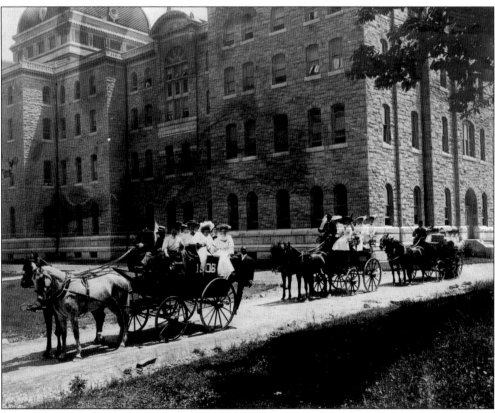

In 1910, students depart Trinity College's South Hall for a Sunday picnic at Rock Creek Park. The young ladies are dressed in their finest: hats, lacy blouses and skirts, or dresses. These fortunate students had a superior Catholic education with a range of academic studies, religious instruction, music lessons, and sports education. (TWU.)

Students line up on a sunny day in their caps and gowns to receive their diplomas in front of South Hall. The building was the first on campus, housing six faculty members and accommodating 19 students. Today, South Hall, whose 225,000 square feet includes the institution's administrative offices, classrooms, and some residential space, is the massive granite centerpiece of the campus. (TWU.)

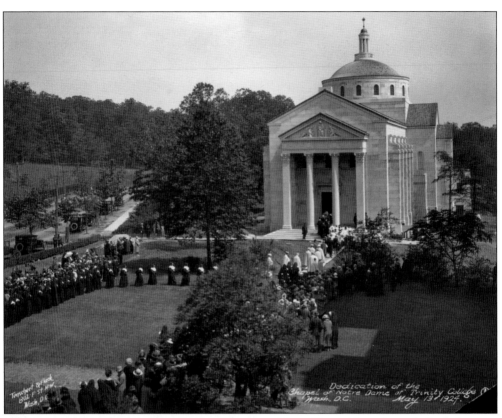

Notre Dame Chapel was dedicated to the Blessed Virgin Mary and under the patronage of the Sisters of Notre Dame de Namur of Trinity College. The dedication ceremony was held on May 13, 1924. (TWU.)

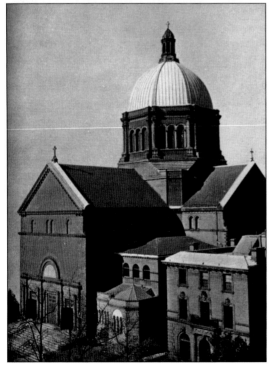

The Cathedral of St. Matthew the Apostle is the premier seat of the archbishop of the Roman Catholic Archdiocese of Washington, DC. The cathedral is in the National Register of Historic Places, and Matthew is the patron saint of civil servants. The cathedral is known for both its solemn yearly Red Mass of the Holy Spirit and the funeral mass of Pres. John F. Kennedy. In 1939, it became a cathedral for the new Archdiocese of Washington. (Cathedral of St. Matthew the Apostle.)

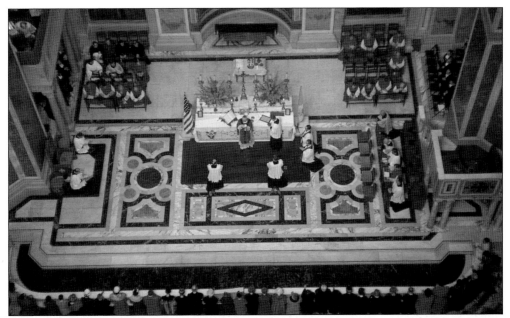

This is a balcony view of the cathedral's altar, where Catholics are kneeling and taking communion. The rich interior of the church boasts a treasure trove of artwork, dedicated to Pope John Paul II's visit in 1979. The archbishops buried in the crypt of the cathedral are Patrick Cardinal O'Boyle and James Cardinal Hickey. (Photograph by Fred Maroon.)

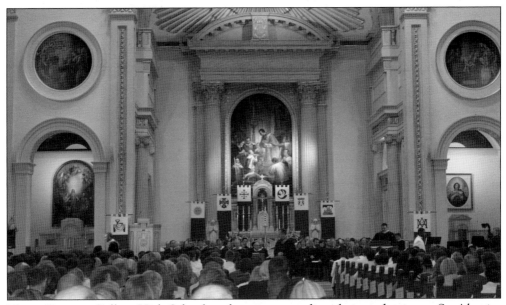

These Gonzaga College High School students are attending their graduation at St. Aloysius Gonzaga Church. Behind the altar is the artwork of Constantino Brumidi, depicting St. Aloysius Gonzaga receiving Holy Communion from St. Charles Borromeo. Brumidi is known for his frescos in the rotunda of the Capitol. Since 1821, Gonzaga has been the oldest Jesuit educational institution in Washington, DC. In 1862, it also served as a military hospital during the Civil War. (NMCAL.)

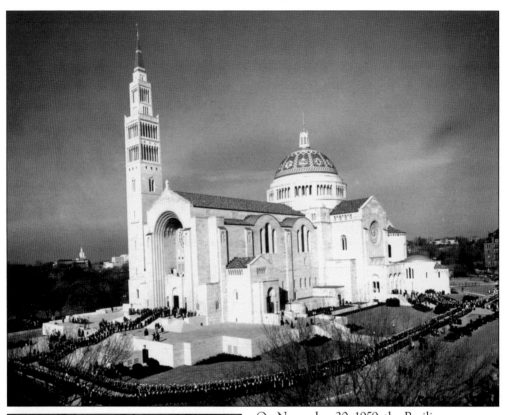

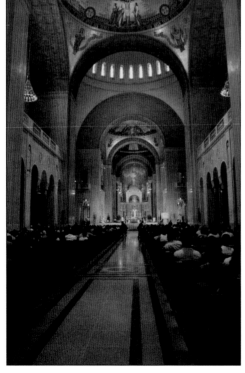

On November 20, 1959, the Basilica of National Shrine of the Immaculate Conception held a dedication triduum with a procession of the Knights of Columbus and the Knights of St. John. Francis Cardinal Spellman gave the prayer and blessing of the national shrine, followed by the celebration of the mass. The Knights of Columbus generously supported the building of the basilica's bell tower. (Above, CUA; left, NMCAL.)

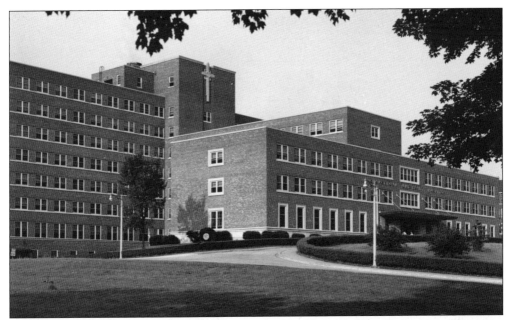

Pictured here in 1947 is the new Georgetown Hospital building. MedStar Georgetown University Hospital is one of the capital area's teaching hospitals, affiliated with Georgetown University School of Medicine and now on Reservoir Road in Washington, DC. Additionally, MedStar Georgetown University Hospital is home to the Lombardi Comprehensive Cancer Care Center and was awarded magnet status by the American Nurses Credentialing Center in 2004. (GU.)

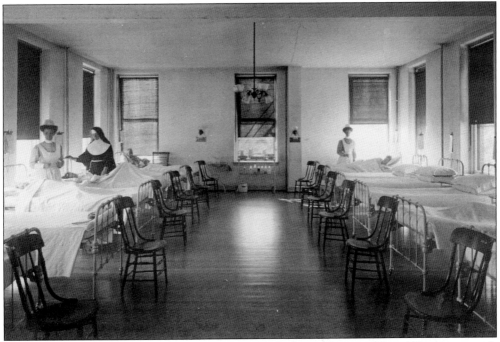

In 1903, Georgetown University Hospital opened a facility to accommodate 100 patients, with the Sisters of St. Francis working tirelessly with nursing students from the training school. The hospital pictured was located at the corner of Thirty-fifth and N Streets NW. (GU.)

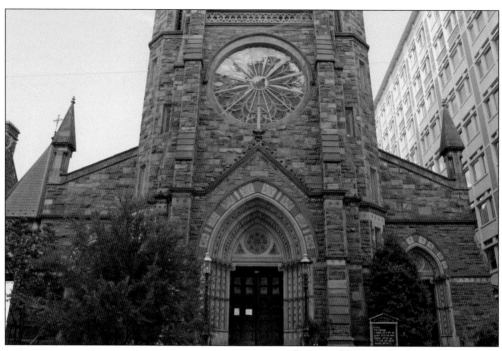

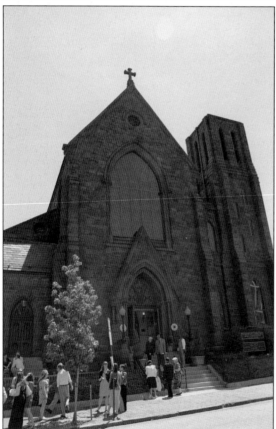

St. Patrick's Catholic Church is the oldest parish in Washington, DC. Founded in 1794 to minister to the stonemasons building the White House and the Capitol, the parish continues to serve the needs of downtown Washington with daily mass and confession, adult education, and cultural activities. Bishop John Carroll appointed Irish Dominican Fr. Anthony Caffry as the first pastor. (St. Patrick's Church.)

St. Joseph's Church on Capitol Hill is known for its proximity to the Capitol, Library of Congress, and Union Station. It was established by German immigrants and modeled after a famous cathedral in Cologne, Germany. James Cardinal Gibbons laid the cornerstone on October 25, 1868, in front of a jubilant crowd of 20,000, including Pres. Andrew Johnson. (NMCAL.)

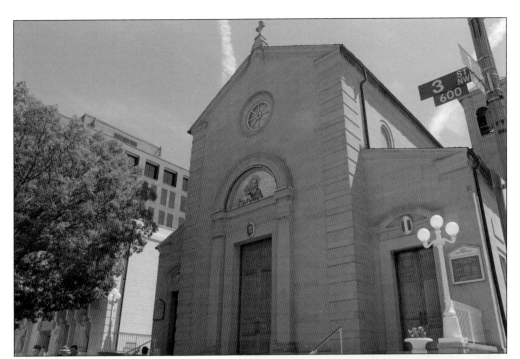

Holy Rosary was established in 1913 and is the only national Italian parish in Washington, DC. It was founded by Father De Carlo, a Paulist priest who made a vow to the Blessed Virgin Mary after a serious illness to raise money to build a new church. Its present home is 596 Third Street NW. (NMCAL.)

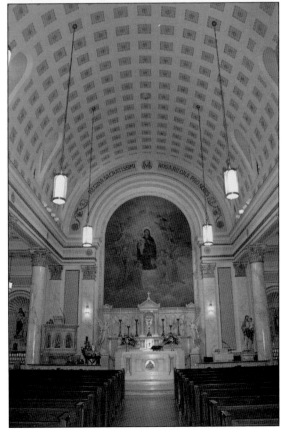

This interior altar reveals Holy Rosary as one of the prettiest churches and honors Italian traditions with an Italian mass for Columbus Day and the Feast of St. Anthony. The striking painting behind the altar is the Virgin Mother with the child Jesus and all the angels surrounding them in glory and praise. Holy Rosary and Casa Italiana community embrace the Sons of Italy in America and the National American Italian Foundation in Washington, DC. (NMCAL.)

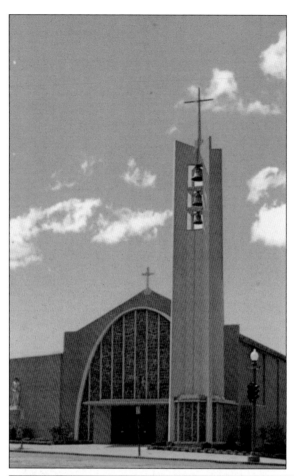

This is a postcard of St. Stephen Martyr Church. In 1993, under the guidance of Fr. Thomas Sheehan, construction of a new parish began in the west end, close to George Washington University. The original church and school were established in 1868 by Fr. Charles White. Pres. John F. Kennedy and First Lady Jacqueline Kennedy attended mass many times here, for it was located very close to the White House. (Both, St. Stephen Martyr Church.)

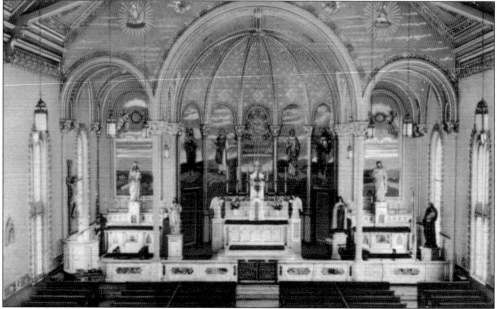

The photograph at right shows the exterior of St. Mary Mother of God Church. The church and St. Mary's School were established in 1845 on Fifth Street in Chinatown. It was first built for the German settlers throughout the city. The early church was constructed with a rectory, school, and convent for the Sisters of Notre Dame. Below is the interior, with the beautiful altar and stained-glass windows. (Both, NMCAL.)

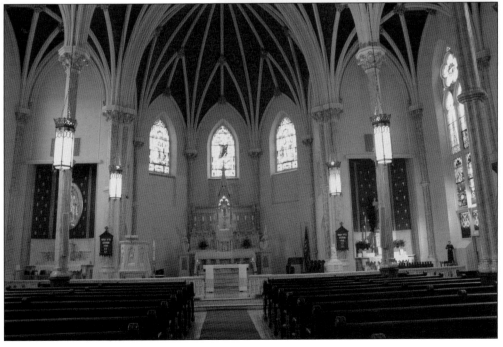

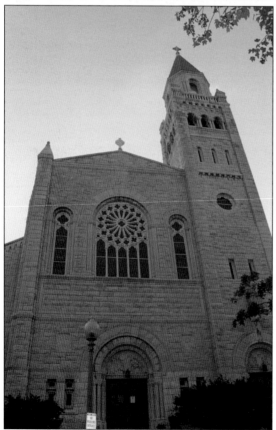

This photograph is of the interior of St. Peter's Church on Capitol Hill. This church was built to accommodate the growing Catholics who lived and worked around the Navy Yard, the arsenal, and the Capitol. In 1820, Fr. William Matthews, pastor of St. Patrick's, and some prominent Catholics, such as Daniel Carroll, William Brent, and James Hoban, first organized a new parish. It is located on the corner of Second and C Street SE and was dedicated on November 23, 1890. (NMCAL.)

On March 17, 1940, a fire destroyed St. Peter's Church just three days after Easter. After the fire, the parish elected to build a fireproof church. It reopened on Easter Sunday, April 13, 1941, and Archbishop Michael Curley presided at the formal ceremony and the 120th jubilee of the parish on November 23, 1941. St. Peter's is home to many Catholics who work in Congress and live in Washington. (NMCAL.)

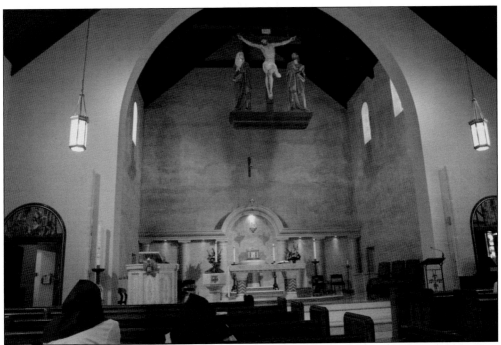

The Church of the Annunciation is located at 3800 Massachusetts Avenue NW and opened on Sunday, July 11, 1943. This photograph is of the interior of the new altar and interior of the church after the Second Vatican Council. In 1937, Archbishop Michael Curley, then the archbishop of Baltimore, Maryland, purchased the property for a church and school. More recently, Pope Benedict XVI visited the church, school, former convent of the Society of the Holy Child Jesus, and parish hall on His Holiness's visit to Washington, DC, in 2008. (NMCAL.)

This is a photograph of the exterior of Epiphany Catholic Church. It was established in 1923 and is located in Georgetown on Dumbarton Street NW. It serves the community of Georgetown and holds a wonderful Christmas bazaar each year. Epiphany is a Christmas feast or festival celebrating the birth of Christ and the Magi's arrival. (NMCAL.)

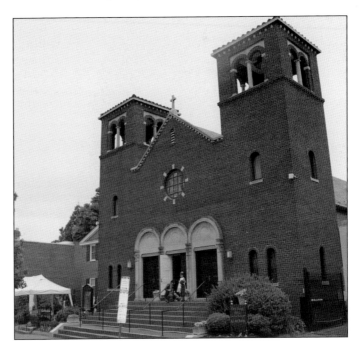

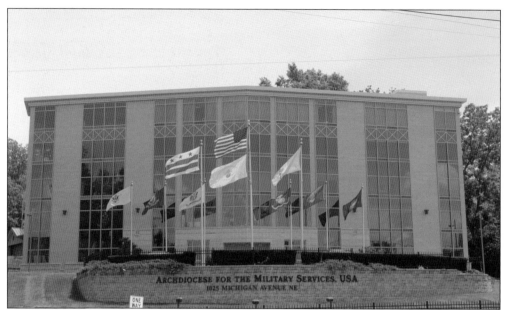

The Archdiocese for the Military Services, USA, building was established in 1985 by Pope John Paul II. The archdiocese offers Roman Catholic pastoral and spiritual services to those serving in the armed forces and other federal services overseas. Archbishop Timothy Broglio, other auxiliary bishops, and priests are serving as military chaplains throughout the world. (NMCAL.)

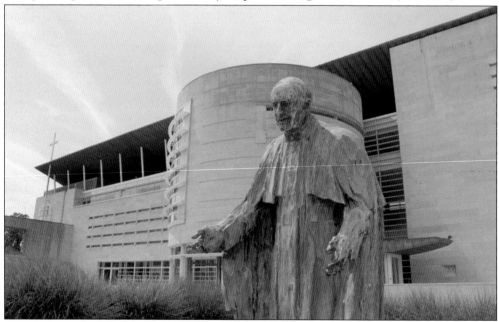

In this photograph is the exterior of the Pope John Paul II Shrine Cultural Center, first opened in March 2011. Adam Cardinal Maida of Detroit, Michigan, was the driving force behind the organization and helped to established its mission as an interreligious think tank and museum dedicated to Pope John Paul II. In 2011, the center was managed by the Knights of Columbus and dedicated its building as a national shrine in honor of St. Pope John Paul II in 2014. (NMCAL.)

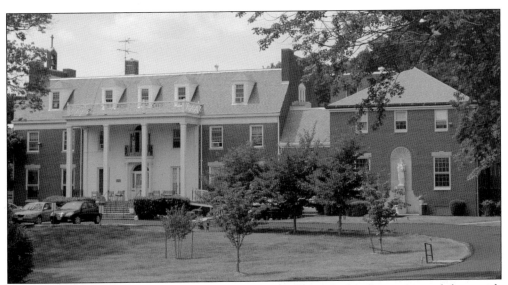

Little Sisters of the Poor home for the aged is a nursing home facility for seniors and those with various levels of disabilities. It is located at 4200 Harewood Road NE near CUA. In 1839, St. Jeanne Jugan founded the order of Little Sisters of the Poor international congregation. In 1871, Fr. Walter Jacob, pastor of St. Patrick's Church, welcomed the sisters from France to care for the aged and the poor. The sisters were first located at 924 G Street NW then 220 H Street NW, finally moving in March 1977 and opening the Jeanne Jugan Residence on Harewood Road. The sisters have entertained notable visitors such as Eleanor Roosevelt, Pres. George W. Bush, and First Lady Laura Bush. They also provided a home for James Cardinal Hickey in his final years. (NMCAL.)

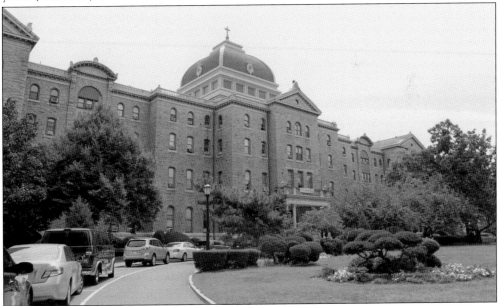

Trinity Washington University is under the trusteeship of the Sisters of Notre Dame de Namur. It is located across from Catholic University of America and has been a university since 2004. It maintains its original status as a liberal arts women's college, but the school admits men and welcomes students of all faiths. (NMCAL.)

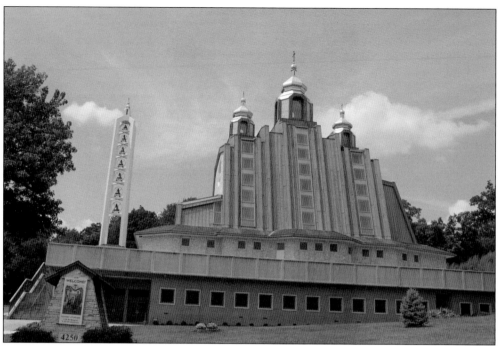

As Catholic immigrants began to grow, so did the Ukrainian population. In 1979, Ukrainian Catholic National Shrine of the Holy Family cornerstone was blessed by Pope John Paul II, and the upper church was dedicated as a national shrine in 2004. It is a member of the sui juris Eastern Catholic churches in communion with the bishop of Rome and popular for their Confraternity of the Most Holy Rosary. (NMCAL.)

Catholic heroes are immortalized in the Capitol's statuary hall. Life-size bronze statues are on display: St. Damien of Molokai, Fr. Jacques Marquette, Fr. Eusebio Kino, Fr. Junípero Serra, Mother Joseph of the Sisters of Providence, and Charles Carroll of Maryland, signer of the Declaration of Independence. (NMCAL.)

Two

CATHOLIC MEN OF FAITH

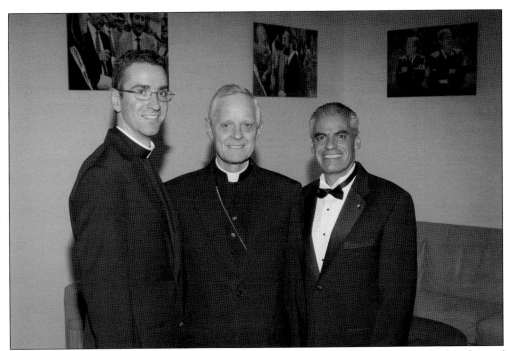

NMCAL Lifetime Achievement honoree Donald Cardinal Wuerl (center), Archbishop of Washington, stands with NMCAL leadership honoree US ambassador to the Holy See Miguel Diaz (right) and Father Anthony Lickteig, secretary to His Eminence, at the Second Annual Roman Gala at the embassy of Italy in 2012. (NMCAL, Peter Stepanek.)

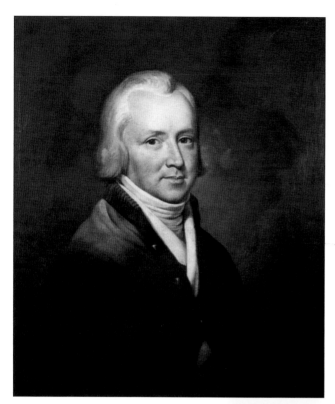

In 1761, young John Carroll joined the Society of Jesus at the age of 25. Due to Pope Clement XVI's suppression of Jesuits in 1773, Carroll left Liege, Belgium, after studying and teaching theology. He was ordained a priest at 34 years old and began his ministry in the American colonies. He was the first American-born Roman Catholic bishop and first archbishop in the United Sates. (CUA.)

John Carroll (1735–1815), archbishop of Baltimore, founded Georgetown University, St. John the Evangelist Parish of Rock Creek, various churches, and the first cathedral in the United States—the Basilica of the National Shrine of the Assumption of the Blessed Virgin Mary in Baltimore, Maryland. In 1808, Pope Pius VII made Baltimore the first archdiocese in the United States. (NMCAL.)

Charles Carroll of Carrollton, Maryland, was a wealthy planter and advocate of American independence. He served as a delegate to the Continental and Confederation Congresses and was later the first US senator from Maryland. Carroll is the only Catholic to have signed the Declaration of Independence. He served as a congressman and US senator in 1789 and was the last surviving signer of the Declaration of Independence. (GU.)

Victor Korvolev, a Russian artist, painted this version of the signing of the Declaration of Independence for NMCAL's collection. On July 4, 1776, the Continental Congress agreed to the Declaration of Independence, and the United States of America was born. (NMCAL.)

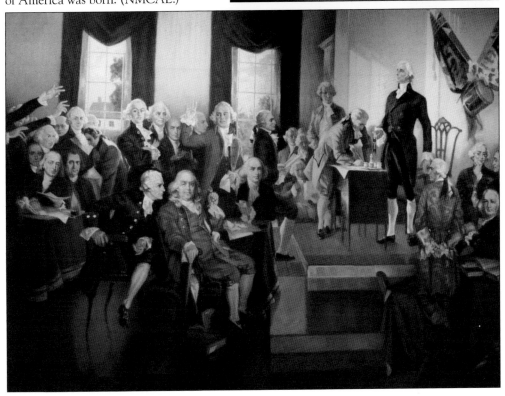

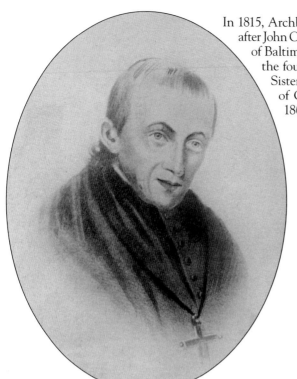

In 1815, Archbishop Leonard Neale became a bishop after John Carroll died and was the second archbishop of Baltimore, Maryland. He was instrumental in the founding of the convent of the Visitation Sisters and school. He was also the president of Georgetown University from 1799 to 1806. (GU.)

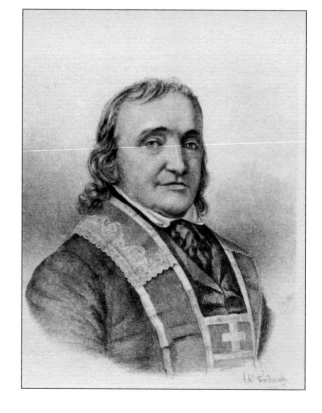

Fr. William Matthews was the pastor of St. Patrick's from 1804 to 1854. He came from Charles County, Maryland, where he was the first American-born priest ordained in the United States by Bishop Carroll. Father Matthews was the nephew of Leonard Neale. (St. Patrick's Church.)

Fr. Jacob Walter was appointed pastor of St. Patrick's in 1860. He helped establish Catholic education and future parishes, including Immaculate Conception, St. Teresa's, and Holy Name. He was Mary Surratt's confessor in prison; she was hanged for treason for involvement in planning the assassination of President Lincoln. (St. Patrick's Church.)

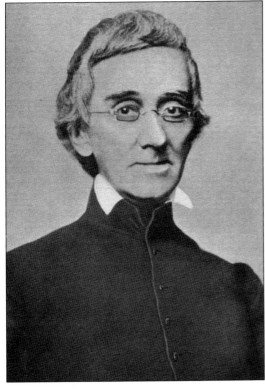

Rev. Charles I. White was an author, *Catholic Mirror* editor, and pastor of St. Matthew's Church and school. Born in Baltimore in 1807, he served mass for Archbishop John Carroll as a boy and knew Sr. Elizabeth Seton and the future Archbishop Gibbons. He founded an old-age home for African Americans and started St. Ann's Infant Asylum with the Sisters of Charity in 1860. (LOC.)

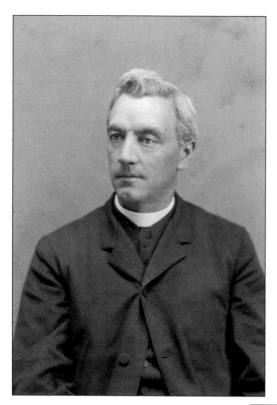

Patrick Healy was the president of Georgetown University from 1873 to 1882. In addition to raising funds for Healy Hall and overseeing its construction, he expanded curriculum. He is believed to be the first African American to earn a doctorate and the first to head a white university. He was born in Georgia to an Irish father, and his mixed-race mother was considered a slave under Georgia law. (GU.)

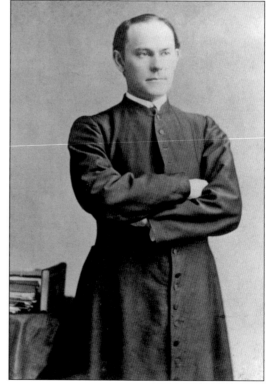

In 1878, Pope Pius IX appointed the Most Reverend John Lancaster as bishop of Peoria. John Lancaster Spalding was the nephew of Archbishop Martin Spalding and was ordained in 1863. He was one of the founders of Catholic University of America and a promoter of education, including Catholic schools in the diocese. (CUA.)

Archbishop Martin Spalding, known for civil rights advocacy, was the seventh archbishop of Baltimore, from 1864 to 1872. He was the former bishop of Louisville, Kentucky, and is regarded as one of the founders and patrons of the American College of Louvain, Belgium. He was a champion of the Catholic school system and frequently lectured at the Smithsonian Institution. Spalding succeeded Archbishop Francis Patrick Kenrick of Baltimore and was installed on August 31, 1864. He established parishes and Catholic institutions, and introduced religious orders. (CUA.)

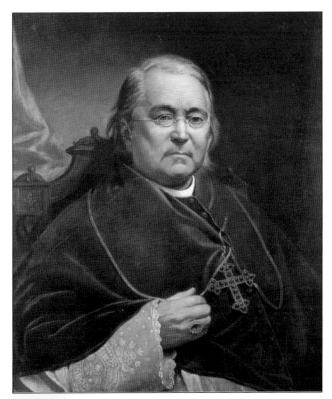

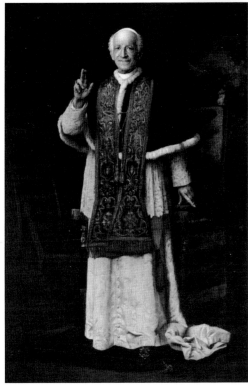

In 1887, Pope Leo XIII sent a letter to James Cardinal Gibbons approving of the charter of the flagship Catholic educational university of high learning. The Third Plenary Council of Baltimore met at St. Mary's Seminary in 1884 and voted to start the Catholic University of America. Pope Leo XII had a significant impact on the development of the Roman Catholic Church in America and is responsible for creating metropolitan sees across America. (CUA.)

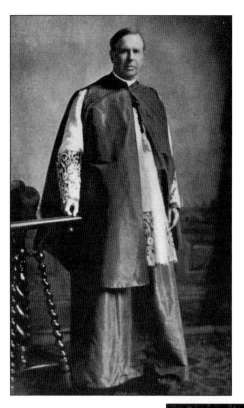

Msgr. Thomas Sim Lee was the driving force to establish a new Cathedral of St. Matthew the Apostle. He purchased land at 1725 Rhode Island Avenue for the new location, and St. Matthew's Church was built in 1892. Msgr. Thomas Sim Lee's grandfather was the governor of Maryland, and his family members were wealthy landowners and patriots of the American Revolution; they also founded St. Mary's Roman Catholic Church in Maryland. The Lees had a winter home in Georgetown. (NMCAL.)

This marble plaque rests on a column in the Cathedral of St. Matthew the Apostle. It was placed in memory of Msgr. Thomas Sim Lee, pastor and builder of the new Cathedral of St. Matthew the Apostle. His ancestry was rich, for his grandfather Thomas Lee was Maryland's governor and his great-grandfather Charles Carroll was the only Catholic to sign the Declaration of Independence. (NMCAL.)

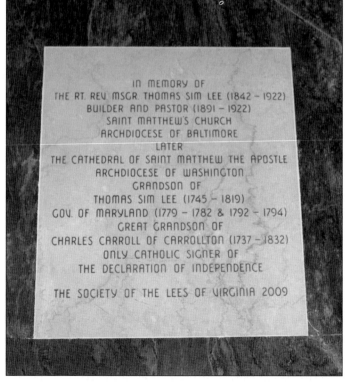

IN MEMORY OF
THE RT. REV. MSGR. THOMAS SIM LEE (1842 – 1922)
BUILDER AND PASTOR (1891 – 1922)
SAINT MATTHEW'S CHURCH
ARCHDIOCESE OF BALTIMORE
LATER
THE CATHEDRAL OF SAINT MATTHEW THE APOSTLE
ARCHDIOCESE OF WASHINGTON
GRANDSON OF
THOMAS SIM LEE (1745 – 1819)
GOV. OF MARYLAND (1779 – 1782 & 1792 – 1794)
GREAT GRANDSON OF
CHARLES CARROLL OF CARROLLTON (1737 – 1832)
ONLY CATHOLIC SIGNER OF
THE DECLARATION OF INDEPENDENCE

THE SOCIETY OF THE LEES OF VIRGINIA 2009

On September 23, 1917, over 10,000 visitors swarmed the Catholic University of America's campus to witness James Cardinal Gibbons bless the foundation stone for the Basilica of the National Shrine of the Immaculate Conception. A large procession including religious orders, archbishops, Knights of Columbus, and Cardinal Gibbons, apostolic delegate John Bonzano and William Cardinal O'Connell, archbishop of Boston, followed. The four-ton block of granite was donated by James Joseph Sexton. (CUA.)

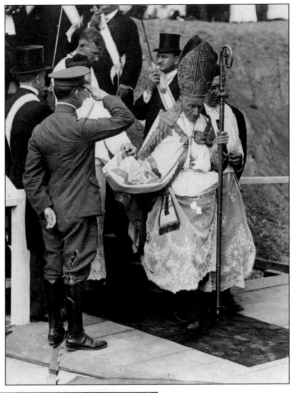

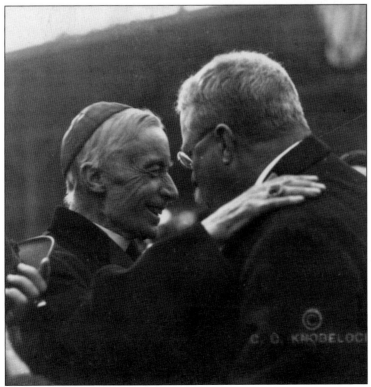

In 1904, James Cardinal Gibbons, archbishop of Baltimore, Maryland, greets Pres. Theodore Roosevelt as they dedicate St. Patrick's Church. Gibbons was a major force in the creation of the Catholic University of America and one of the most powerful influences in religion and politics from 1877 until 1921. Gibbons defended the Knights of Labor union, supported Catholics in World War I, and increased church membership. (CUA.)

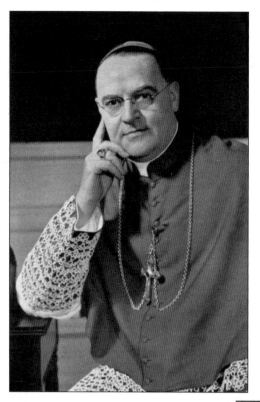

Archbishop Michael Curley was appointed the 10th archbishop of Baltimore, Maryland, by Pope Benedict XV and succeeded James Cardinal Gibbons. Curley advocated for education, and he established 66 schools in 18 years. In 1923, Curley established Catholic Charities and the Society of the Propagation of Faith in 1925. Pope Pius XII separated Washington, DC, from the Archdiocese of Baltimore in 1939 to form a new Archdiocese of Washington. Curley was named the first archbishop of Washington. (CUA.)

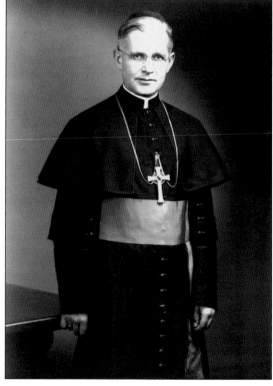

Bishop Lawrence Shehan's first assignment was St. Patrick's Church in Washington, DC; he was later made director of Catholic Charities in Washington from 1929 to 1945. Shehan was appointed pastor of St. Patrick's from 1941 to 1945, and he helped to end racial segregation at the parochial school in 1942. He was the bishop of Bridgeport, later the archbishop of Baltimore (1961–1974), made a cardinal in 1965, and was an American prelate of the Roman Catholic Church. (CUA.)

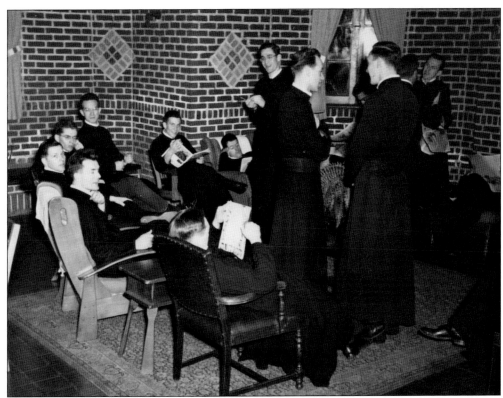

Young Paulist seminarians are seen chatting and reading at St. Paul's College. These men of faith are at Catholic University of America for their graduate studies in theology. St. Paul's College serves as home for the Paulist priests who serve the local and national Catholic Church through a variety of apostolates, including reconciliation, evangelization, ecumenism, and mass communication. (CSP.)

In this photograph, members of a graduating class of young Paulist seminarians stand together on the front steps of St. Paul's College. Third from the left in the first row is Francis Cardinal Spellman, archbishop of New York, holding his hat. Cardinal Spellman presided over the ordination on May 3, 1956, of the largest class in St. Paul's history. (CSP.)

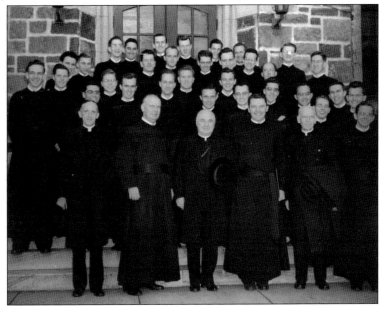

The Venerable and Most Reverend Fulton Sheen was an American bishop and theologian most known for his *The Catholic Hour* radio show from 1930 to 1950. His Emmy Award–winning television show drew more the 30 million viewers from 1961 to 1968. Known as a famous televangelist, Bishop Sheen also taught theology and philosophy at the Catholic University of America. (CUA.)

The Most Reverend Amleto Cicognani is standing with two Dominican priests at a mass at St. Patrick's Church. His Eminence was the fourth of six apostolic delegates to the United States, serving from 1933 to 1958. He was appointed by Pope Pius XI and served as a liaison between the American hierarchy and the Vatican for 25 years. (CUA.)

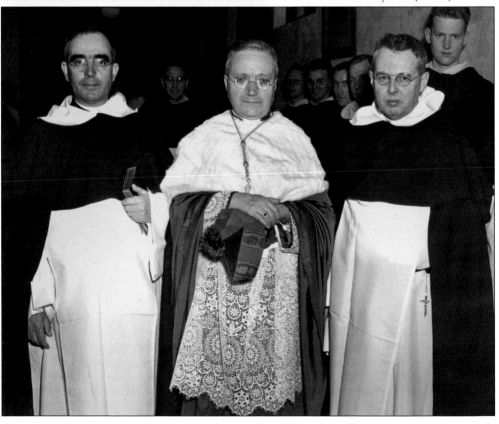

Msgr. James H. Ryan, CUA's rector, speaks with Pres. Franklin Roosevelt on July 14, 1933, after FDR had received an honorary degree. On October 8, 1936, Ryan spoke up and urged millions of listeners on the radio to vote for Roosevelt. Ryan gave the benediction at Roosevelt's inaugurations in 1937 and 1945. (CUA.)

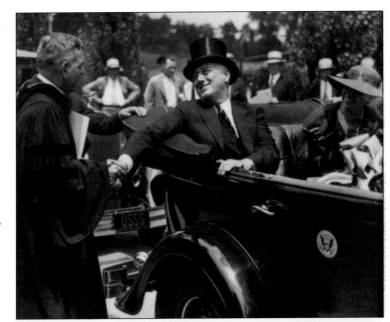

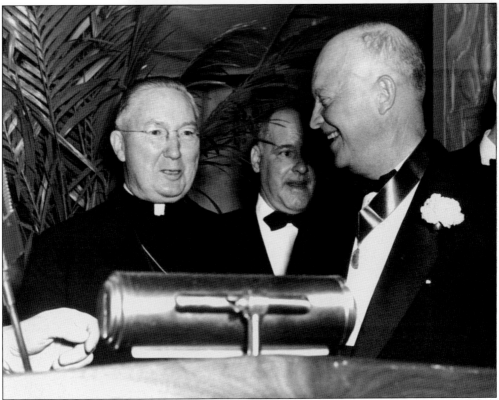

At the podium, Patrick Cardinal O'Boyle, archbishop of Washington, speaks with former president Dwight D. Eisenhower at the Fides House on August 28, 1963. The Catholic neighborhood Fides House facility provided aid to citizens. O'Boyle was asked to say the benedictions at inauguration events for Harry Truman in 1949 and Dwight D. Eisenhower in 1953. (CUA.)

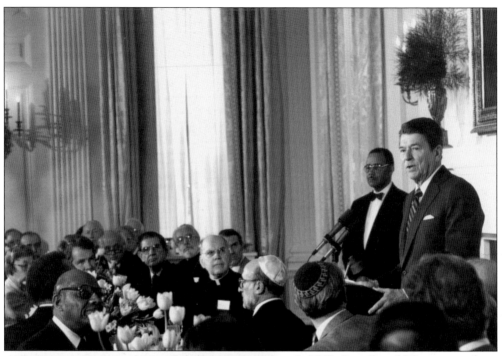

In 1982, Pres. Ronald Reagan speaks to an interreligious group at the White House. William Cardinal Baum was in attendance with rabbis and preachers. President Reagan first met Pope John Paul II at the Vatican Library on Monday, June 7, 1982, and their 50-minute talk focused on Poland and the Soviet Union's dominance in Eastern Europe. (CUA.)

On Sunday, October 4, 1992, Pres. George H.W. Bush walks with his friend James Archbishop Hickey after the traditional Red Mass at Cathedral of St. Matthew the Apostle. A Red Mass is a mass for judges, attorneys, and government officials. It takes place on the Sunday before the first Monday in October, before the Supreme Court convenes. The John Carroll Society started the sponsorship in 1952. (CSM.)

Fr. Gilbert Hartke speaks with Pres. Richard Nixon and CUA students at the White House. Father Hartke, known as the White House priest, had relationships with many presidents—John F. Kennedy, Lyndon B. Johnson, Richard Nixon, and Jimmy Carter. In 1963, he was asked by the White House to stay with President Kennedy's remains until the official funeral. (CUA.)

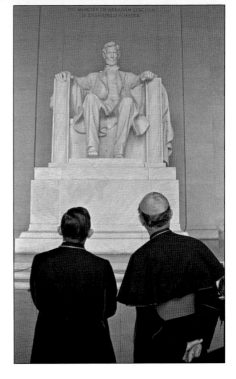

Primate and cardinal priest Jozef Cardinal Glemp, archbishop of Warsaw, Poland, visits Washington, DC. In this photograph, Glemp (right) and James Cardinal Hickey chat in front of the Lincoln Memorial. Glemp was a faithful ally of Pope John Paul II and Solidarity leader and later Polish president Lech Walesa, steering communism to democracy in 1989. (*Catholic Standard*, photograph by Michael Hoyt.)

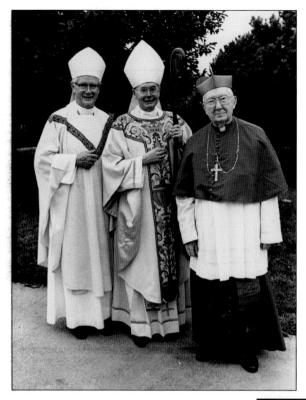

In this iconic photograph are three cardinals of the Archdiocese of Washington. They are, from left to right, James Cardinal Hickey (1980–2000), William Cardinal Baum (1973–1980), and Patrick Cardinal O'Boyle (1947–1973). Their burial crypts can be seen at the Chapel of St. Francis of Assisi in the Cathedral of St. Matthew the Apostle. (*Catholic Standard*, photograph by Michael Hoyt.)

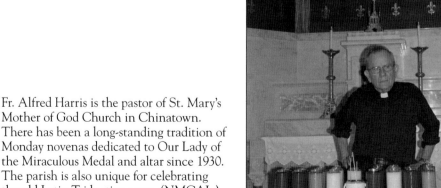

Fr. Alfred Harris is the pastor of St. Mary's Mother of God Church in Chinatown. There has been a long-standing tradition of Monday novenas dedicated to Our Lady of the Miraculous Medal and altar since 1930. The parish is also unique for celebrating the old Latin Tridentine mass. (NMCAL.)

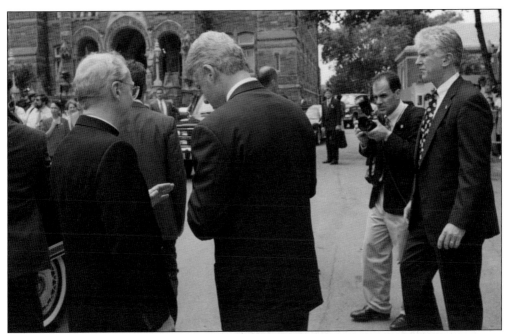

A former student leader and alumnus of Georgetown University, Pres. Bill Clinton is an honorary member of Kappa Kappa Psi and was elected to Phi Beta Kappa; he attended the Edmund A. Walsh School of Foreign Service. Here, President Clinton (back to camera, right) pays a visit to his alma mater and is chatting with GU president Leo Donovan. (GU.)

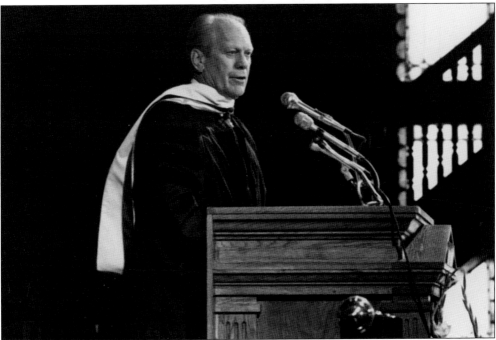

It is a tradition at Georgetown University to invite presidents to speak in front of Old North. Since George Washington spoke in 1797, fourteen presidents have accepted. Here, former president Gerald Ford accepts an honorary degree at a ceremony in 1983. (GU.)

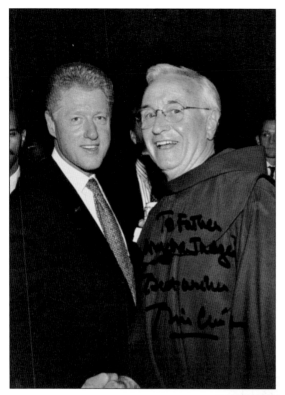

Pres. Bill Clinton and Fr. Mychal Judge stand together at a Catholic charity event. Father Judge asked the president to autograph the photograph, but he never received it. The father was killed on September 11, 2001. He was a fire chaplain and had been in the North Tower at the World Trade Center helping victims and giving last rites when the building started to collapse. (NMCAL.)

In 1986, James Cardinal Hickey, archbishop of Washington; Pio Laghi, Apostolic Nuncio; and Mother Teresa are pictured here in front of the Missionaries of Charity home in Anacosta. This convent was dedicated by Cardinal Hickey for the sisters to care for the homeless and terminally ill, including those with AIDS. Cardinal Hickey's special love for those in need was recognized when Catholic Charities named its new headquarters the James Cardinal Hickey Center. (*Catholic Standard*, photograph by Michael Hoyt.)

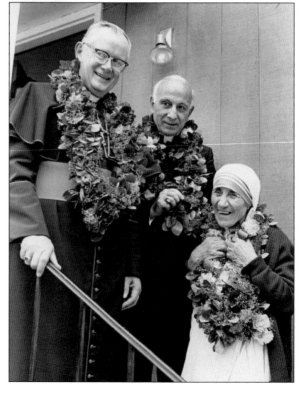

Pope John XXIII reigned from 1958 to 1963 and was canonized a saint in 2014. This pontiff was an advocate of human rights, including for the unborn and the elderly. This peaceful pope offered to mediate between Pres. John F. Kennedy and Nikita Khrushchev during the Cuban Missile Crisis in October 1962. (CUA)

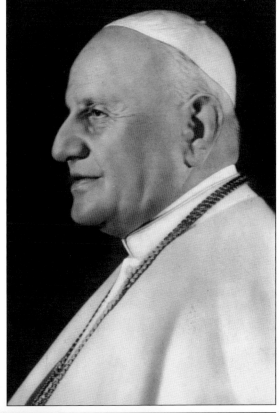

In 2001, Theodore Cardinal McCarrick greets Monsignor Jameson, pastor of the Cathedral of St. Matthew the Apostle, for the inauguration of McCarrick as the archbishop of Washington. Cardinal McCarrick retired in 2006 and is currently the counselor at the Center for Strategic and International Studies. (Cathedral of St. Matthew the Apostle.)

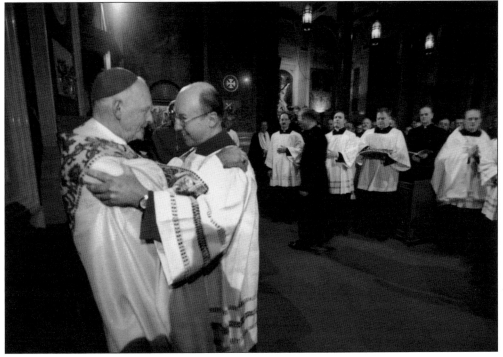

Adam Cardinal Maida (second from left) of the Archdiocese of Detroit was a key leader in the founding of the Pope John Paul II Shrine. Here at the cardinal's 80th birthday party are Brother Joseph Britt (left), archivist; Fr. Steven Boguslawski, OP (third from left), from Dominican House Studies; and an unidentified man. (NMCAL.)

Three

CATHOLIC WOMEN OF FAITH

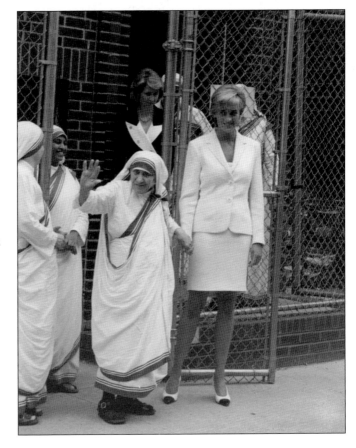

In 1997, Mother Teresa of Calcutta and Princess Diana of Wales, an Anglican, visit the Missionaries of Charity in New York. In 1979, Mother Teresa was awarded the Nobel Peace Prize for her humanitarian work. Diana was known for her work with children, AIDS awareness, and the international Red Cross. These two great global humanitarians died six days apart in 1997. (NMCAL.)

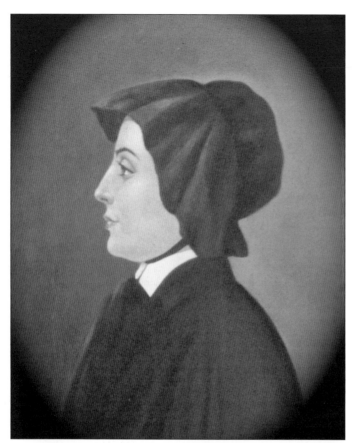

Mother Elizabeth Ann Seton was a founding Sister of Charity in Emmetsburg, Maryland, in 1809. Her missions were education, opening schools, writing textbooks, and training sisters to be teachers and nurses. She was a mother of five children in her early life, a widow at 31 years old, and an Episcopalian who converted to Roman Catholicism at a time—in the early 1800s—when there was much prejudice against Catholics. Canonized in 1975 by Pope Paul VI, she was the first American-born saint. Below are the original black bonnet, wooden crucifix, glass rosary beads, and diary used by St. Elizabeth Seton. They are owned by the Sisters of Charity of New York. (Both, NMCAL.)

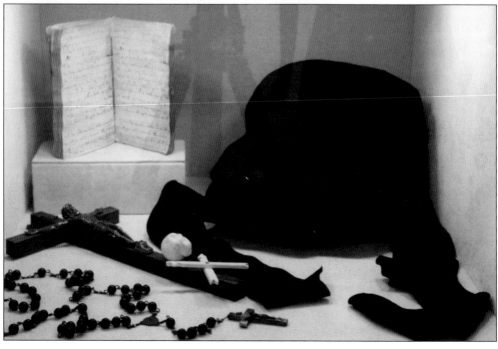

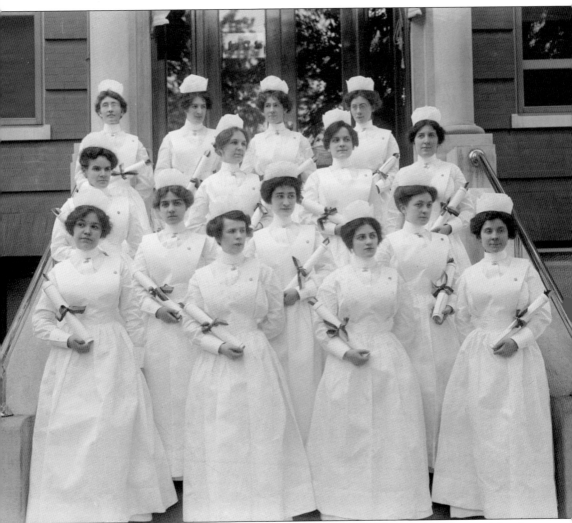

In this image made between 1911 and 1916, a Georgetown University Hospital Nursing School class picture shows graduates at Gaston Hall. These first female students received their diplomas from Rev. David Hillhouse Buel, SJ, and helped open the door for other women to continue their education in health care. (GU Hospital Public Relations.)

At the invitation of Pres. Abraham Lincoln in 1861, the Daughters of Charity of St. Vincent de Paul founded Providence Hospital. The sisters began their service to district residents who were sick, poor, and vulnerable. President Lincoln signed an act of Congress to the charter Providence, the longest continuously operating hospital in Washington, DC. (LOC.)

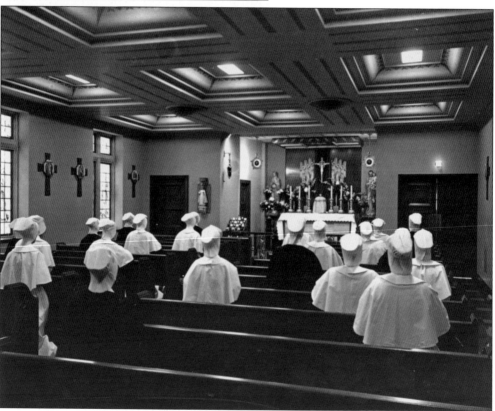

This is the chapel of Georgetown Hospital; a group of nurses is kneeling and praying. The chapel services offers masses, sacraments, anointing of the sick, and reconciliation for Catholic patients and their families. It is one of the sacred spaces in the hospital, and chaplains are available 24 hours a day. (GU.)

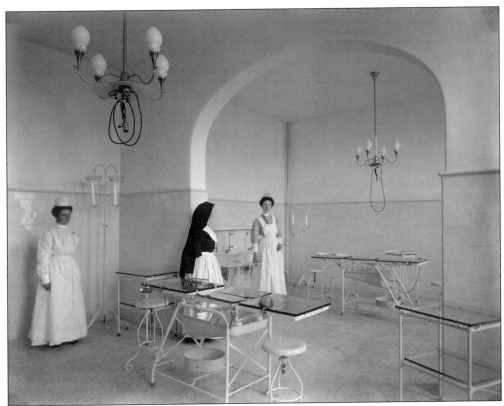

This c. 1909 photograph shows the emergency room in Georgetown Hospital located at Thirty-fifth and N Streets. The sister in the center is a member of the Sisters of St. Francis of the Third Order of Philadelphia. The sisters had an agreement with the hospital administrators in 1898 to manage the hospital. (GU.)

The new Georgetown University Hospital opened on Reservoir Road NW in 1947. An ambulance carries a Sister of St. Francis on a stretcher, greeted by staff before being taken into the emergency ward of the new hospital. (GU.)

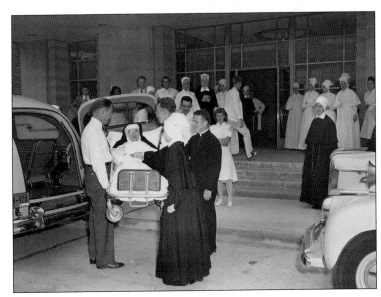

In 1827, Irish-born Sr. Julia McGroarty, founder of Trinity College, was educated by the Sisters of Notre Dame in Cincinnati, Ohio. In 1848, she professed her vows and became a teacher and the administrator of the Academy of Notre Dame in Philadelphia, Pennsylvania. She was the second mother superior of the Sisters of Notre Dame de Namur in the United States. Noting the lack of higher education facilities for Roman Catholic women, she established Trinity College. (TWU.)

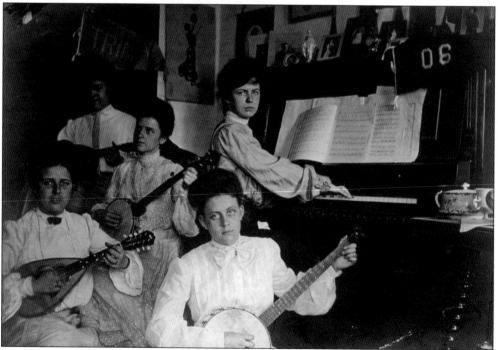

Most prominent and wealthy Catholic families sent their daughters to be educated at Trinity College by the Sisters of Notre Dame de Namur. In the early 1900s, these young ladies rehearse in the students' parlor. The music students are pictured here playing piano, mandolins, and banjos. A Trinity banner is pinned on the wall, and photographs, religious statues, and mementos grace the top of the piano. (TWU.)

In May 1925, these students are carrying a chain of daisies on their shoulders at their graduation from Trinity College. Until the 1950s, the daisy train tradition honored students for their contributions to college life, leadership, and class spirit. Parents and guests stand in the background as the young ladies parade in front of South Hall. (TWU.)

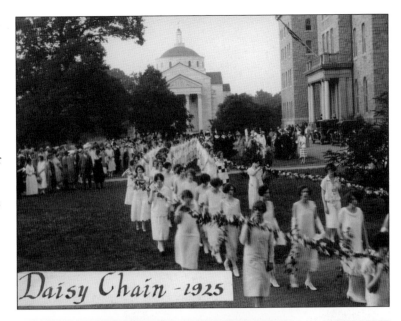

Daisy Chain - 1925

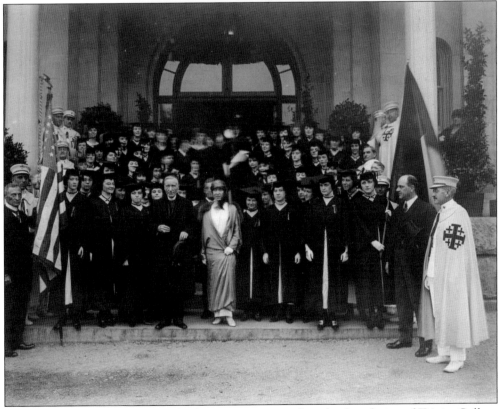

Cardinal Gibbons, archbishop of Baltimore, participated in the foundation of Trinity College in 1897. In 1919, His Eminence stands with Elizabeth, Queen of the Belgians, and the Trinity graduating class of 1920. The queen was presented the first honorary degree, and two postwar scholarships were established for French students. (TWU.)

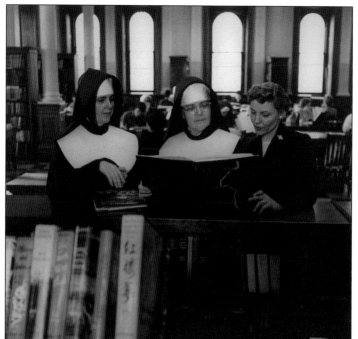

This 1960s photograph shows Sr. Helen Sheehan (center), librarian of Notre De Namur at Trinity College. She organized the 200,000 volumes at the library and acquired scholarly information for the Trinity community. Sr. Dorothy Beach (left) and Mary Klein are assisting in organizing, maintaining, and cataloging. In 1978, the library was named after and dedicated to Sister Sheehan. (TWU.)

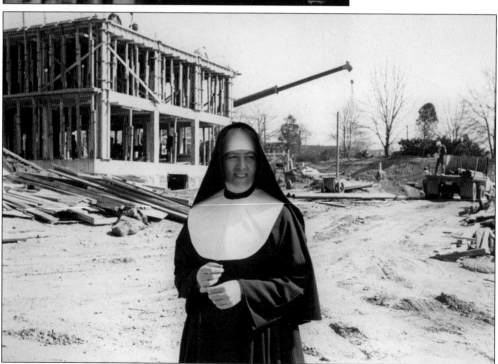

This is a photograph of Sr. Margaret Claydon, PhD, a Sister of Notre Dame de Namur and president of Trinity Washington College. In 1959, Sister Claydon set outstanding goals for the college's fundraising, educational development, and campus expansion. She stands in front of Kerby Hall's construction. A national leader, Sister Claydon was the youngest to be appointed to that office and the youngest college president in the country in 1959. (TWU.)

Trinity Washington University president Patricia McGuire is one of the most admired women in Washington, DC. President since 1989, she graduated from Trinity, earned her law degree at and later served as assistant dean for development at Georgetown Law. As president, she has provided leadership for the paradigm shift in Trinity's student population. McGuire is a nationally recognized advocate for issues affecting higher education and has received several awards in recognition of this leadership. (TWU.)

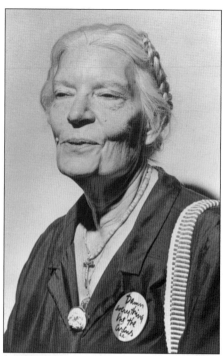

Dorothy Day, known as Servant of God, is pictured with a button that reads, "Damn everything but the circus." In 1917, Day went to picket at the White House with the suffragists and endured her first arrest for civil disobedience, imprisonment in Virginia, and a 10-day hunger strike. Day was an journalist, editor, social activist, and devout Catholic who worked closely with Peter Maurin, establishing the Catholic Worker movement for the homeless. (Marquette University.)

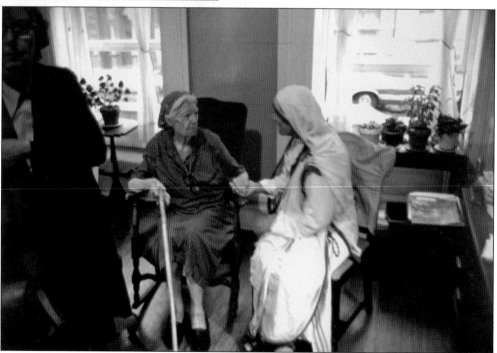

Mother Teresa (right) and Dorothy Day hold hands and lock eyes in this very personal meeting between two holy people who understand the love for Jesus. These two remarkable women shared many things in common: their work for the poor, pacifism, and imitation of St. Therese of Lisieux. They were strong enough to move mountains and taught that prayer works miracles. (Bill Barrett.)

Mother Teresa holds a child, Anna Marie Fardig, in her arms while attending the National Right to Life Convention in June 1985. Mother Teresa spoke about abortions, the right to life, and dignity to more than 1,500 convention attendees. The Gift of Peace home provides shelters for persons with AIDS and other terminal illnesses. "Mother Teresa enthralled us with her wisdom, kindness, and holiness," said Cardinal Hickey. (*Catholic Standard*, photograph by Michael Hoyt.)

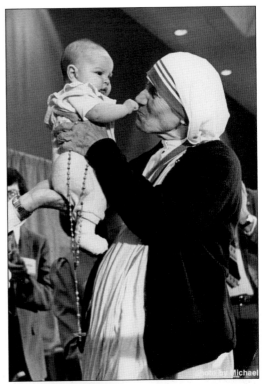

Mother Teresa, a native Albanian and Nobel Peace Prize winner, receives communion from James Cardinal Hickey during her Gift of Peace visit to Washington, DC, on November 29, 1986. Cardinal Hickey said, "May years ago, God called Mother Teresa to a life of service to the poorest of the poor, Mother Teresa's life and work can not be explained apart from a clear, uncompromising faith and her profound love for the Lord Jesus." (*Catholic Standard*, photograph by Michael Hoyt.)

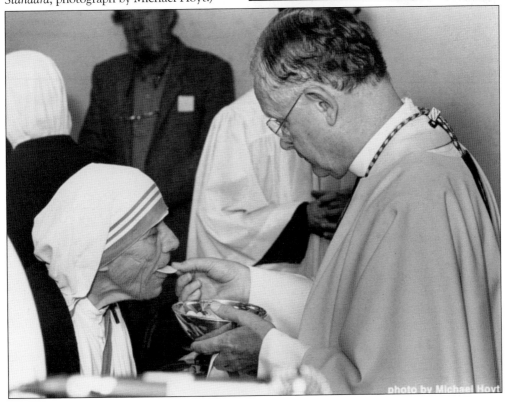

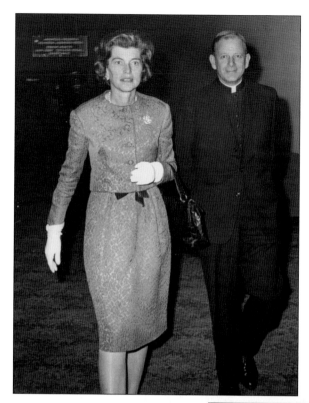

In 1990, Eunice Kennedy Shriver, recipient of the James Cardinal Gibbons Award and sister of Pres. John F. Kennedy, is walking with an unidentified priest at Catholic University of America. Shriver was a tireless campaigner on behalf of the mentally handicapped, a strong advocate for the Special Olympics, and a pro-lifer. She took her stand, along with many Democratic leaders, to object to the party's support for abortion. In 1984, President Reagan awarded her the Presidential Medal of Freedom. (CUA, photograph by Shields.)

Ethel Skakel Kennedy, mother of 11 children and wife and widow of Attorney General Robert Kennedy, was raised Catholic at the Convent of the Sacred Heart in New York, New York. She attended Manhattanville College of the Sacred Heart where she met roommate Jean Kennedy and dated Robert. James Cardinal Hickey greets Kennedy at a Catholic fundraiser in the 1980s. (*Catholic Standard*, photograph by Michael Hoyt.)

In 1929, Grace Kelly (later Her Serene Highness Princess Grace of Monaco) was born into the prominent Irish Catholic Kelly family of Philadelphia. In this photograph, Princess Grace is visiting Catholic University of America to prepare for a poetry reading for the American Wildlife Fund. (CUA.)

In May 24, 1961, guests depart following a luncheon in honor of Prince Rainier III and Princess Grace of Monaco at the White House with President Kennedy and First Lady Jacqueline Kennedy. These American Catholic women were known for their elaborate Roman Catholic weddings and beauty. (JFKLM, photograph by Abbie Rowe.)

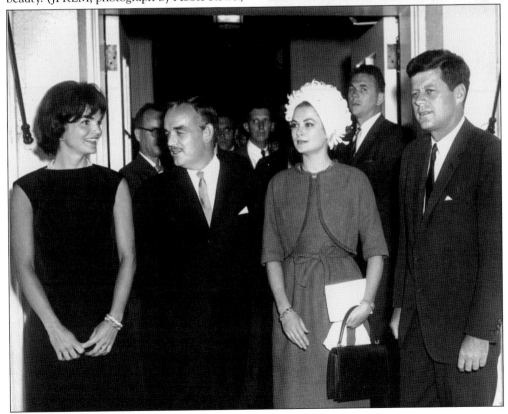

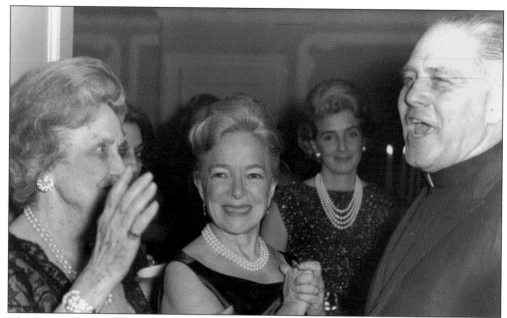

The Broadway and film star Helen Hayes (center) laughs with Fr. Gilbert Hartke (right), a Dominican priest, founder of the Department of Speech and Drama at Catholic University of America. He produced 60 plays and built a theater at CUA, which was named after him in 1970. Hayes, a longtime Catholic friend of Father Hartke, made her final stage appearance at CUA's Hartke Theater in Eugene O'Neill's classic *Long Day's Journey Into Night*. (CUA.)

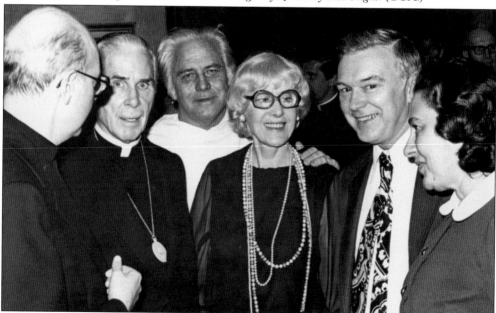

In 1946, congresswoman and ambassador Clare Boothe Luce (center) poses with Clarence Walton (second from left). She was a convert to Catholicism after losing her 19-year-old daughter, Ann Brohaw, in a car accident. She was assisted by Msgr. Fulton Sheen, known for many conversions of faith, in joining the Roman Catholic Church. To the left is Bishop Sheen with Fr. Gilbert Hartke behind Luce's right shoulder. (CUA.)

Mother Angelica is the founder of the Eternal World Television Network in Irondale, Alabama. She is an American Franciscan nun of the Poor Clares of Perpetual Adoration and best known for her television personality, books, and lectures. Here in February 1990 she is invited to the National Catholic Prayer Breakfast in Washington, DC. (*Catholic Standard*, photograph by Michael Hoyt.)

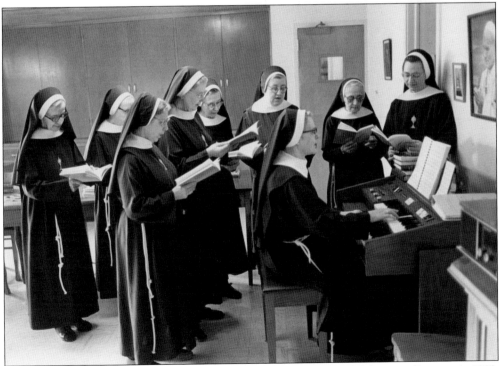

A choral session of nine sisters was held at the Poor Clare of Perpetual Adoration Convent in 1983. The Poor Clare nuns live together in a monastery located across the street from the Franciscan monastery. They spend their lives in prayer, community, and joy. The nuns fulfill their days with celebration of the Eucharist, liturgy of the hours, and Eucharistic Adoration. (*Catholic Standard*, photograph by Michael Hoyt.)

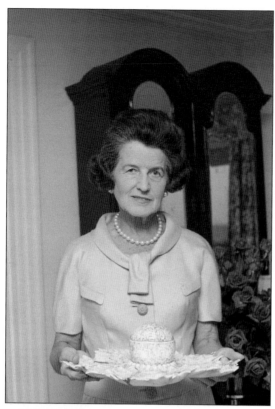

Rose Fitzgerald Kennedy is pictured here in 1962. She was a devout Irish Catholic, philanthropist, socialite, and the wife of Joseph Kennedy, a politician and businessman. She was the proud mother of nine children, including the first Catholic president, John F. Kennedy. In 1951, Pope Pius XII bestowed on Rose the highest papal honorific, Papal Countess, in recognition of her exemplary motherhood and many charitable works. (JFKLM.)

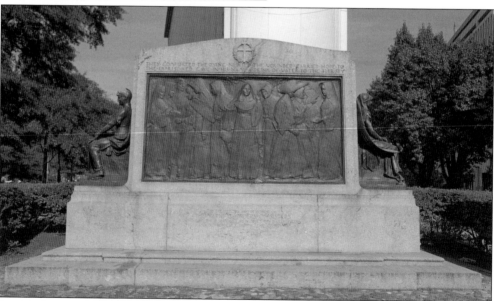

Jerome Connor designed the Nuns of the Battlefield public monument. It is a tribute to more than 600 nuns who nursed soldiers on both sides of the Civil War. The bronze panel bas-relief shows 12 nuns dressed in traditional habits. Unveiled in 1924, it is inscribed as follows: "They comforted the dying, nursed the wounded, carried hope to the imprisoned, gave in His name a drink to the thirsty." (NMCAL.)

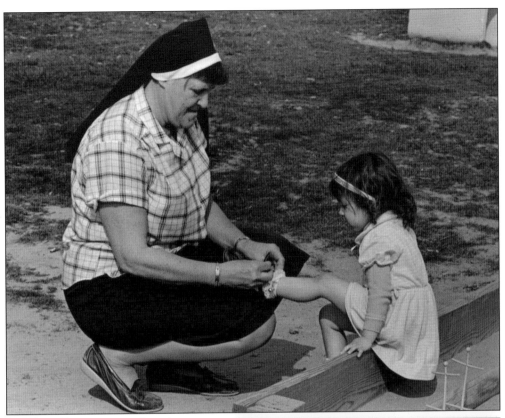

Sr. Eileen Connors, a teacher, ties the shoe of a young school girl on the sidewalk in front of the Pallotti day care center. In 1981, the center at St. Mary's of the Mills School provided day care for 63 children. The Pallotti learning center's mission is based on love and respect for God, self, and others. It was founded in 1973 by the Pallottine Missionary Sisters. (*Catholic Standard*, photograph by Michael Hoyt.)

Dolores Hope, singer and philanthropist, was a devout Catholic and supported many Catholic charities, including Our Lady of Hope Chapel in the lower level of Basilica of the National Shrine of the Immaculate Conception. The chapel was dedicated to her husband's mother, Avis Hope. Dolores and comedian Bob Hope were married for 69 years. Bob was given the papal honor of Knight Commander of St. Gregory the Great and was a convert. (NMCAL.)

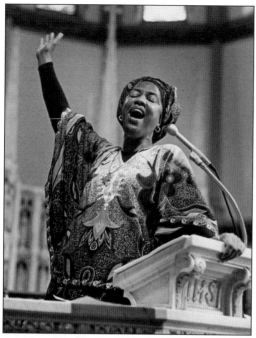

Sr. Thea Bowman was a Franciscan Sister of Perpetual Adoration and a Roman Catholic religious sister, teacher, and scholar. She was a convert to the Catholic faith at age nine and attended Catholic University of America. Bowman was the founder of the National Black Sisters Conference, which helped African American women in Catholic institutes. Here, she is singing at St. Augustine's Church in 1986. (*Catholic Standard*, photograph by Michael Hoyt.)

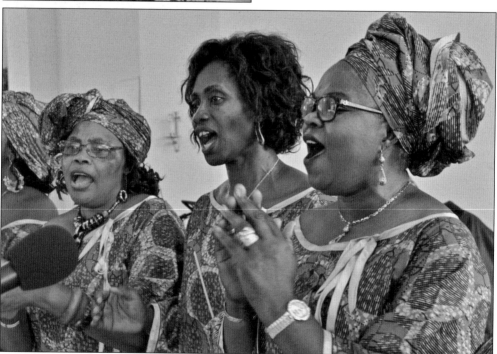

In 1968, these singers and members of the National Black Sisters have been shouting "Glory! Hallelujah!" These Catholic women are religious but from different congregations. They draw strength and courage from God and help promote positive self-image among themselves and their people. In 1858, St. Augustine's Catholic Church was formed for black Catholics. Today, it has developed into one of the most popular churches and is known for its choir. (*Catholic Standard*, photograph by Michael Hoyt.)

In 1973, Nellie Jane Gray, founder of the March for Life, started the annual march after the Supreme Court decision legalizing abortion. She pioneered the pro-life movement as president for 40 years and regularly spoke at the annual rally on the National Mall. Gray served as a corporal in the Women's Army during World War II and was a convert to the Catholic faith. (*Catholic Standard*, photograph by Michael Hoyt.)

In 1992, Christina Cox, NMCAL founder, received a holy blessing from Pope John Paul II to build the first national museum of Catholic art in the United States. At a St. Peter's Basilica mass diplomatic audience, Cox asked the pontiff to bless the venture. His Holiness made the sign of the cross, placed his hand on the top of her head, and asked the Lord to bless the new museum in America. (NMCAL.)

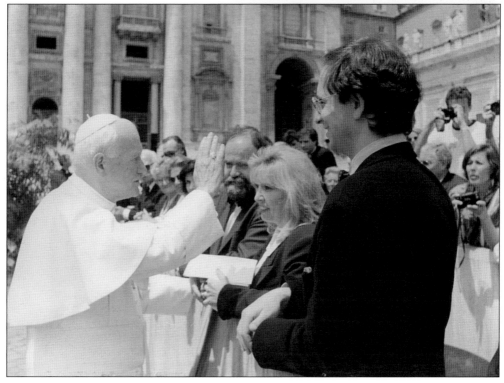

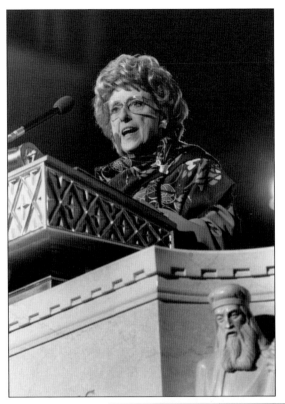

Congresswoman Lindy Boggs received an honorary degree from Catholic University of America in 1991. Lindy was the wife of Congressman Hale Boggs and became a congresswoman after her husband's death in 1972. She was mother to lobbyist Thomas Boggs, journalist Cokie Roberts, and mayor of Princeton Barbara Sigmund. Her diplomatic career soared when Pres. Bill Clinton appointed her ambassador to the Vatican at the age of 81. Below, former American ambassador to the Holy See Lindy Boggs (center) poses at the embassy of Italy with NMCAL honoree and archbishop of Washington Donald Cardinal Wuerl (left), and honoree Miguel Diaz, former ambassador to the Holy See. In 2012, Ambassador Boggs was 97 years old and in very good spirits; she passed away the following year. (Left, *Catholic Standard*, photograph by Michael Hoyt; below, NMCAL, Peter Stepanek.)

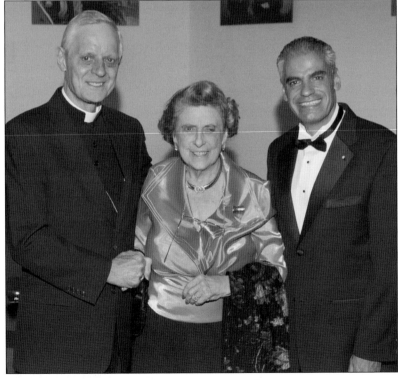

Four

A CATHOLIC PRESIDENT

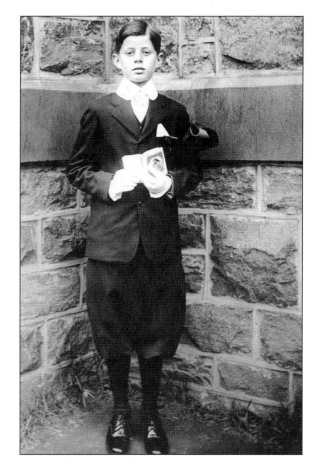

In 1928, John F. Kennedy poses after his confirmation. Born in 1917, he was raised in the Roman Catholic tradition and was taught his religion at home by his mother, Rose. He was an altar boy with his brother Joe Jr. Throughout his life, John went to mass and befriend nuns, priests, and pontiffs. In 1961, he became the first Roman Catholic president of the United States. (JFKLM.)

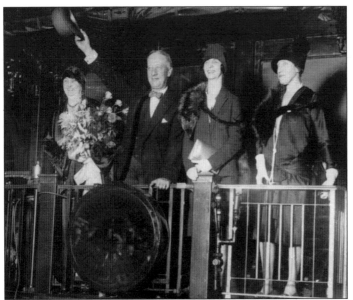

Alfred E. Smith is shown with, from left to right, his wife, Emily, daughter Katherine, and sister Mary on the back of a train for the presidential campaign. The four-time New York governor was the first Roman Catholic candidate to run for president, in 1928. His presidential campaign was confronted by virulent anti-Catholicism. The Ku Klux Klan spent $5 million to publish and distribute vicious lies and anti-Catholic propaganda to hundreds of newspapers. (GU.)

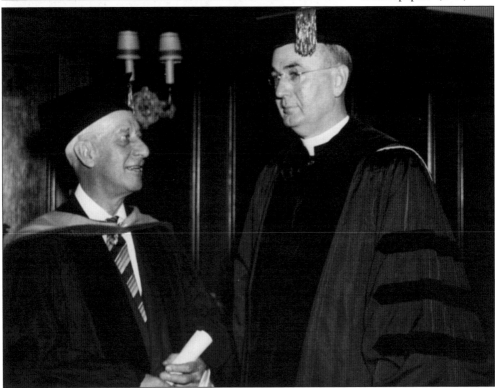

Alfred E. Smith stands with Fr. Arthur O'Leary, president of Georgetown University, as he attends a graduation ceremony for his friend Dan Rooney on June 10, 1941. Father O'Leary was the president of Georgetown University from 1935 to 1942. Smith's bid for the presidency in 1928 proved he refused to accept the rules of a primarily Protestant society and culture. He earned the respect of minorities, for he stood up for the Catholic, Jewish, and African American communities, which perpetuated sympathy and sincere love for Smith. (GU.)

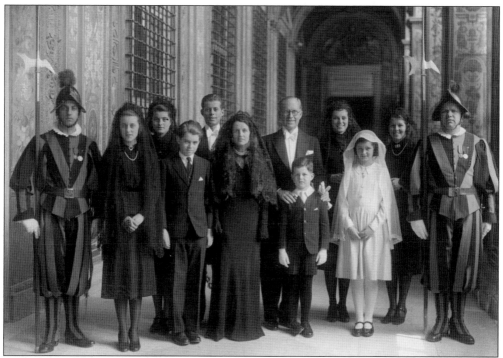

In 1937, President Roosevelt appointed Joseph Kennedy ambassador to the United Kingdom. In 1939, Ambassador Kennedy was appointed a special representative to attend Pope Pius XII's papal coronation. Eugenio Cardinal Pacelli, former friend of Rose Kennedy, had visited their home in 1936. The Kennedys' entourage poses here with two Swiss guards before an audience with the pope. Young Teddy received his first Holy Communion from His Holiness. (JFKLM.)

Congressman John F. Kennedy speaks with Archbishop Richard Cushing of Boston, Massachusetts. In 1953, Cushing married John and Jackie Kennedy, and he baptized Caroline Kennedy in 1957. In 1961, His Eminence performed a prayer invocation at Kennedy's inauguration, and he led the president's funeral mass at the Cathedral of St. Matthew the Apostle on November 25, 1963. (JFKLM.)

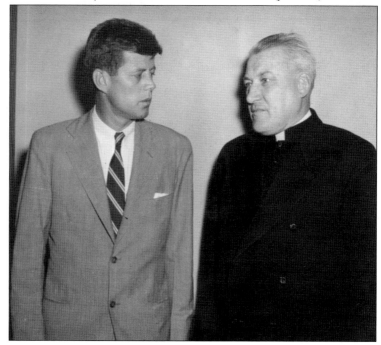

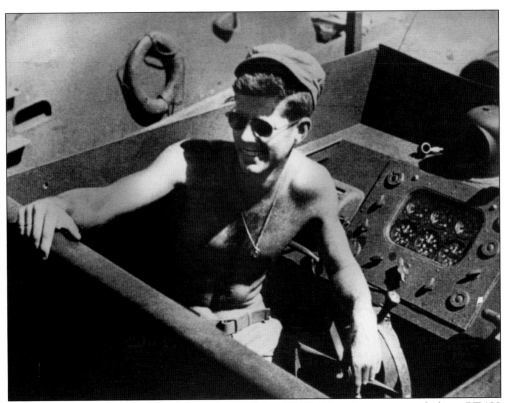

Lt. John F. Kennedy is sitting in the cockpit of the World War II motor torpedo boat *PT-109* in the summer of 1943. Kennedy was assigned to the South Pacific as commander of the patrol torpedo boat. While out on a military mission, a Japanese destroyer suddenly struck, splitting it in half. (JFKLM.)

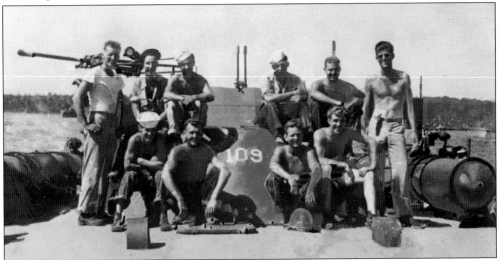

This photograph is of the crewmen of *PT-109* in the Solomon Islands, taken in 1943 before the Japanese attacked their boat. From left to right are (first row) Charles Harris, Maurice Kowal, Andrew Kirksey, and Lenny Thom; (second row) Allan Webb, Leon Drawsy, Edger Mauer, Edmund Drewitch, John Maguire, and Lt. John F. Kennedy. (JFKLM.)

In May 1942, Joseph "Joe" Kennedy Jr., Navy pilot (right), and John F. Kennedy, Navy lieutenant, pose together for this World War II portrait. After John's rescue mission in the South Pacific, he was declared a hero. In 1944, his brother Joe signed up for a serious flying mission in Europe and was killed during the mission. Kennedy's parents created a foundation, and the destroyer USS *Joseph P. Kennedy Jr.* was named in his honor. (Frank Turgeon, JFKLM.)

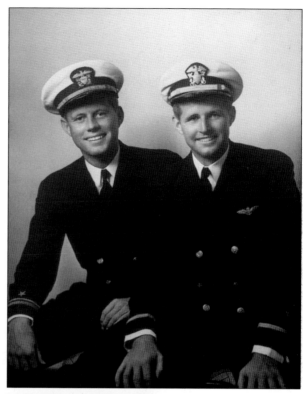

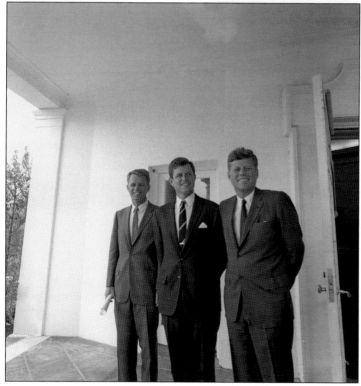

The Roman Catholic brothers took the Washington political arena by storm. All three Kennedy brothers—Bobby (left), Ted (center), and Jack—stand together in this photograph at the White House in 1962. John was the president, Robert was the US attorney general, and Edward became a US senator representing Massachusetts. (JFKLM.)

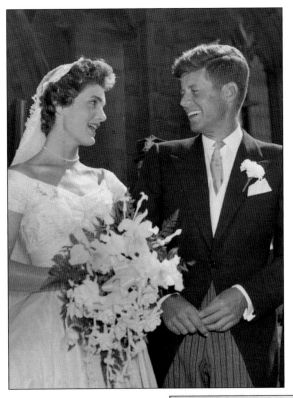

On September 12, 1953, John F. Kennedy married Jacqueline Bouvier at St. Mary's Church in Newport, Rhode Island, and the reception was held at the Bouviers' summerhouse, Hammersmith Farm. More than 750 guests filled the church for the ceremony presided over by Archbishop Cushing. Following the 40-minute ceremony, a papal blessing was read. Jacqueline's dress was the creation of Ann Lowe, an African American dressmaker. (Toni Frisell, JFKLM.)

Robert F. Kennedy was John's best man. His ushers were Edward M. Kennedy, Charles Bartlett, Michael Canfield, George Smathers, K. LeMoyne Billings, Torbert Macdonald, Charles Spalding, James Reed, Benjamin Smith, Joseph Gargan, R. Sargent Shriver, Paul B. Fay Jr., and Hugh D. Auchincloss III. Jacqueline Bouvier's matron-of-honor was Lee Bouvier Canfield. Her maid-of-honor was Nina Auchincloss, and her flower girl was Janet Auchincloss. Her bridal attendants were Nancy Tuckerman, Martha Bartlett, Ethel Skakel Kennedy, Jean Kennedy, Shirley Oakes, Aileen Travers, Sylvia Whitehouse, and Helen Spaulding. (JFKLM.)

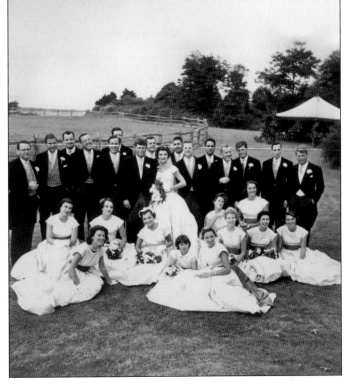

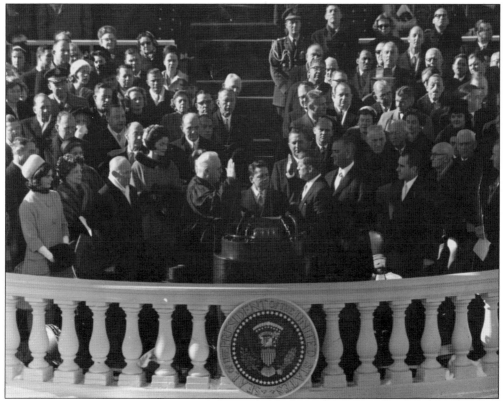

John F. Kennedy was sworn in as the 35th president on January 20, 1961, a cold and blistering day. Nearly one million people were present to witness the first Catholic president's inauguration, and millions more viewed it on television. (Above, JFKLM; below, NMCAL.)

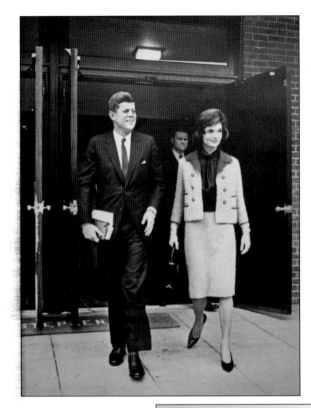

President Kennedy and Jacqueline often attended a local church close to the White House. Here, they are leaving Sunday mass at St. Stephen Martyr Church in Foggy Bottom, Washington, DC, on November 12, 1961. The first lady is wearing her famous pink Chanel suit. St. Stephen's was considered by the Secret Service to be more secure than other Catholic churches in the area. (St. Stephen Martyr Church.)

President Kennedy greets the Sisters of St. Joseph from Brighton, Massachusetts, from the Catholic Church of the Archdiocese of Boston. The Kennedys supported many Catholic charities, and the sisters accepted an invitation to visit Washington, DC. (JFKLM.)

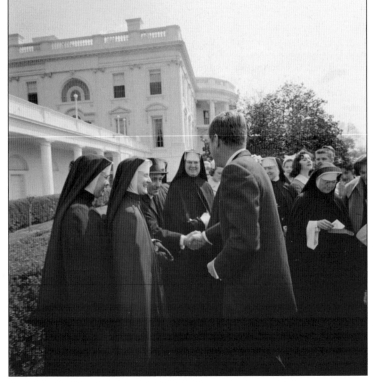

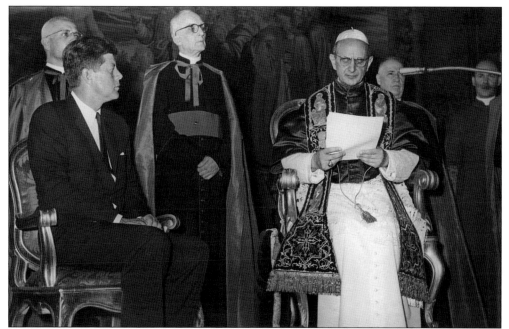

President Kennedy made a Vatican pilgrimage to visit Pope Paul VI on July 2, 1963, just a few months before the president's assassination. His sister Jean Kennedy Smith accompanied him on the trip, along with Secretary of State Dean Rusk. President Kennedy received a gift from the pontiff of a replica of Michelangelo's *Pieta*. (JFKLM.)

In 1962, on her way to India, First Lady Jacqueline Kennedy visits seminarians with Archbishop Martin O'Connor, rector of Pontifical North American College in Rome, Italy. She wore a full-length black dress of simple but elegant cut with a high collar and long sleeves. The highlight of her trip was visiting with Pope John XXIII. It was one of the longest private audiences Pope John ever granted. (JFKLM.)

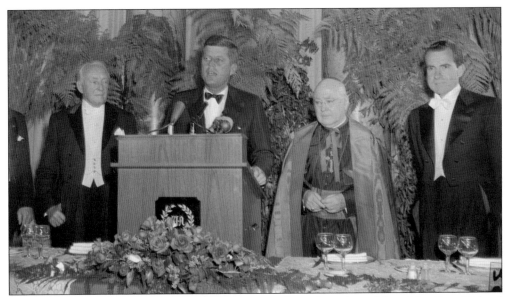

In 1960, New York archbishop Francis Spellman invited presidential candidates Vice Pres. Richard Nixon (right) and Sen. John F. Kennedy (speaking) to the Alfred E. Smith Memorial Dinner at the Waldorf Astoria. The dinner was a high-end political fundraiser and Catholic tradition. Senator Kennedy praised the work of Alfred E. Smith and compared their roles in combating anti-Catholicism. Kennedy also battled many anti-Catholic protesters in the South during his presidential campaign. (JFKLM.)

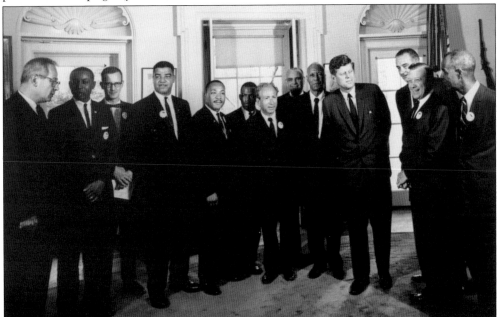

Pres. John F. Kennedy (fourth from right) met with civil rights leaders Rev. Martin Luther King Jr. (fifth from left) and John Lewis (sixth from left) at the White House on August 28, 1963, after the March on Washington. After the nonviolent, successful march, many Americans felt joy, peace, and inspiration. After Reverend King delivered his "I Have a Dream" speech, he and the other leaders were was invited to meet the president. (JFKLM.)

President-elect John F. Kennedy shakes hands with Fr. Robert Casey after attending mass at Holy Trinity Church in Georgetown on the morning of his inauguration on January 20, 1961. He and Jacqueline frequented mass at Trinity when he lived at 3307 N Street NW in Georgetown during his presidential campaign. (LOC.)

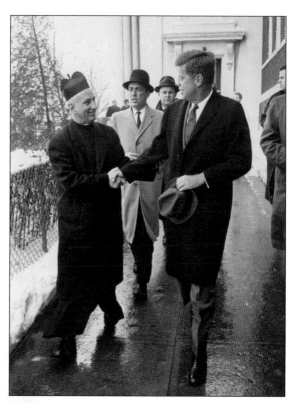

This bronze memorial plaque hangs on the gate outside Holy Trinity Church. It tells a story of how the president attended his last mass in Washington just before his visit to Dallas, Texas, and his untimely death on November 22, 1963. It also includes a quotation from Robert Lewis Stevenson's poem "Requiem." (LOC.)

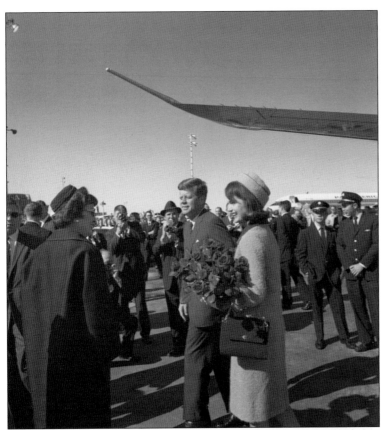

At left, President Kennedy and the first lady disembark Air Force One at Dallas Airport on November 22, 1963, at 11:40 a.m. They were presented a bouquet of red roses as they walked to the fence to greet a crowd of well-wishers. Kennedy was assassinated one hour later by sniper Lee Harvey Oswald in the presidential motorcade and was pronounced dead at Parkland Hospital at 1:00 p.m. Below, Lyndon Johnson made the decision to bring President Kennedy's coffin back to Washington on Air Force One. (Both, JFKLM.)

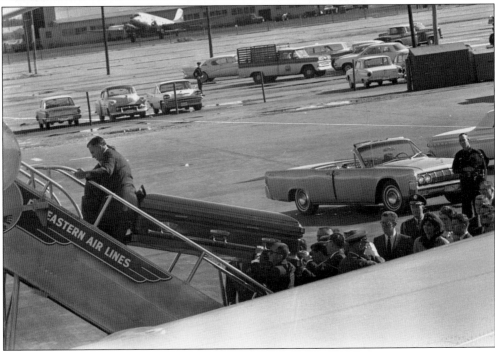

Following the assassination of Pres. John F. Kennedy on November 22, 1963, Vice Pres. Lyndon Johnson takes the presidential oath of office to become the 36th president of the United States. Jacqueline Kennedy (right) remains in her blood-stained pink suit, and Lady Bird Johnson (left of her husband) looks on as Judge Sarah Hughes swears Johnson in as the new president. Johnson rests his hand on JFK's book of Catholic missal. (JFKLM.)

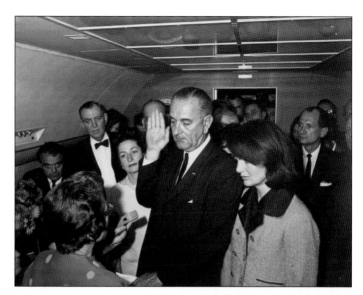

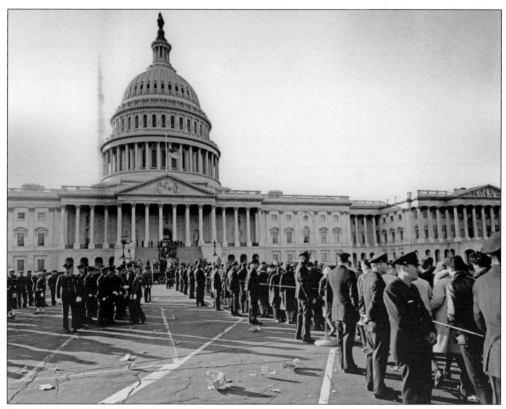

On the Sunday after the assassination, Kennedy's flag-draped coffin was carried on a horse-drawn carriage that once carried Pres. Abraham Lincoln to the Capitol. Throughout the day and night, hundreds of thousands lined up to view the guarded casket. Jacqueline Kennedy requested that two prominent Catholic priests, Fr. Gilbert Hartke and Msgr. Robert Paul Mohan, remain with the body until the official funeral. (JFKLM.)

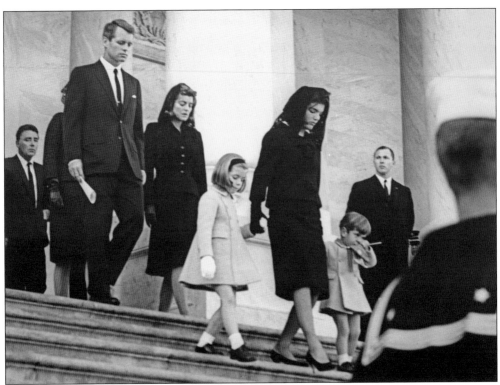

Jacqueline Kennedy led the funeral procession with Attorney General Robert Kennedy (second from left above, left below) and Sen. Ted Kennedy (right below). Former presidents and members of Congress formed a military formation to proceed from the White House down Pennsylvania Avenue and down Seventeenth Street to Connecticut Avenue. The group walked from the White House to the Cathedral of St. Matthew the Apostle for the requiem mass. Moments after the casket was carried down, Jacqueline whispered to her son John Jr. to salute his father's coffin. (Both, JFKLM.)

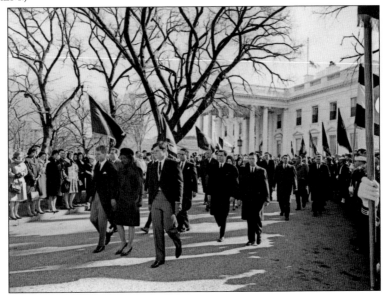

On November 25, 1963, Bishop Phillip Hannan delivered the eulogy at the funeral of Pres. John F. Kennedy at the Cathedral of St. Matthew at the request of Jacqueline Kennedy. He proudly read aloud the principal passage from the president's inaugural address. Hannan had known Kennedy and was an informal advisor during his time in the White House. The principal celebrant of the mass was Richard Cardinal Cushing of Boston, Massachusetts. (CUA.)

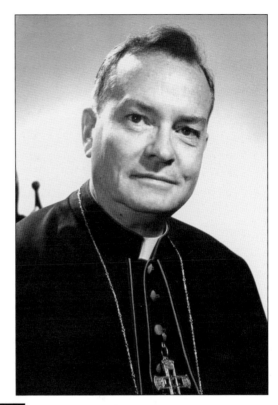

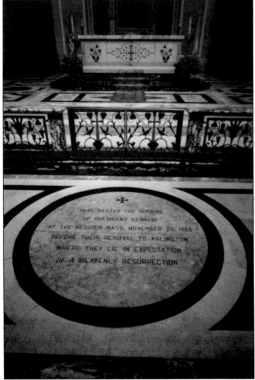

President Kennedy's funeral was held at the Cathedral of St. Matthew the Apostle at 1725 Rhode Island Avenue. Pictured here is an inlaid marble plaque in front of the sanctuary gates commemorating the spot where President Kennedy's casket rested at the requiem mass on November 25, 1963. (NMCAL.)

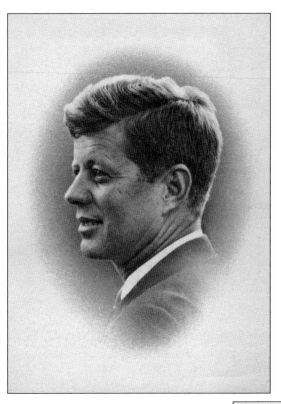

A prayer card was distributed at the Cathedral of St. Matthew the Apostle for the funeral. On the front of the prayer card is a photograph of John Fitzgerald Kennedy, and the back lists his title and birth and death dates. (Both, Cathedral of St. Matthew the Apostle, archivist Dick Schmidt.)

JOHN FITZGERALD KENNEDY

President of the United States

May 29, 1917 - November 22, 1963

Dear God,
 Please take care of your servant
 John Fitzgerald Kennedy

Now the trumpet summons us again—not as a call to bear arms, though arms we need—not as a call to battle, though embattled we are—but a call to bear the burden of a long twilight struggle, year in and year out, "rejoicing in hope, patient in tribulation"—a struggle against the common enemies of man: tyranny, poverty, disease and war itself . . .

In the long history of the world, only a few generations have been granted the role of defending freedom in its hour of maximum danger. I do not shrink from this responsibility—I welcome it. I do not believe that any of us would exchange places with any other people or any other generation. The energy, the faith, the devotion which we bring to this endeavor will light our country and all who serve it—and the glow from that fire can truly light the world . . .

With a good conscience our only sure reward, with history the final judge of our deeds, let us go forth to lead the land we love, asking His blessing and His help, but knowing that here on earth God's work must truly be our own.

The long line of black limousines passed the Lincoln Memorial and crossed the Potomac River. At the end of the burial services, Jacqueline Kennedy lit the eternal flame to burn continuously over the grave of the late president. (Suzy Maroon, photograph by Fred Maroon.)

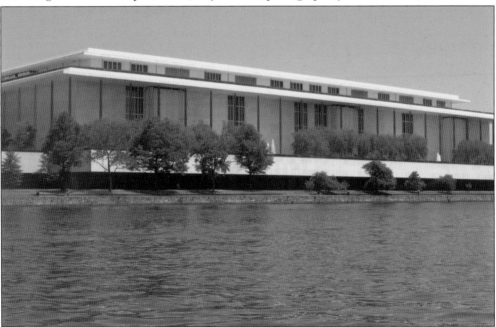

The John F. Kennedy Memorial Center for the Performing Arts was named after the 35th president of the United States in 1964. It is located on the Potomac River, and since 1978 the Kennedy Center Honors have been awarded annually by the board of trustees to artists for their lifetime contributions to the performing arts. (NMCAL.)

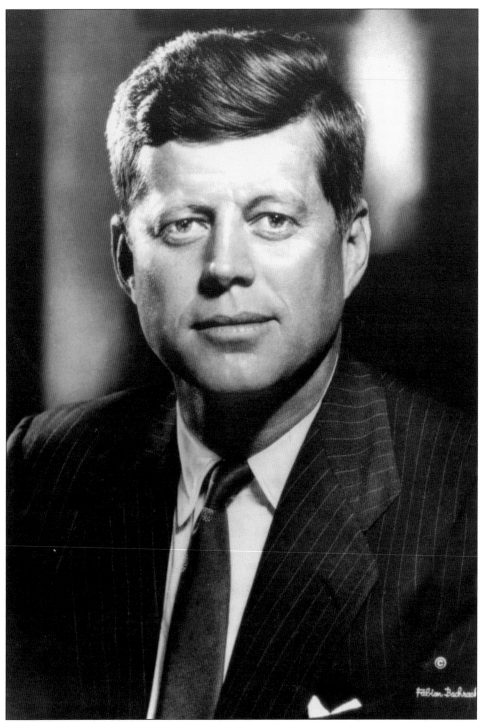

Hundreds of people gathered in Washington, DC, for both the president's inauguration and funeral, and millions watched the events on television. Kennedy will be known for his leadership, personality, and great accomplishments. He said, "My fellow Americans, ask not what your country can do for you, ask what you can do for your country." (JFKLM.)

Five

CATHOLICS ON CAPITOL HILL, MILITARY, LABOR, AND AMBASSADORS

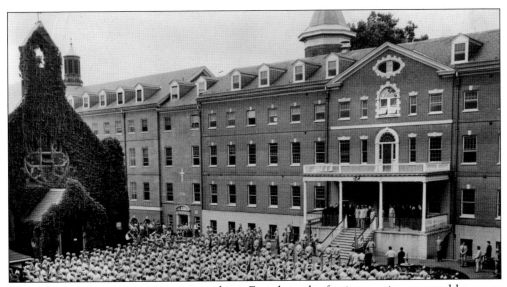

These Georgetown University were studying French in the foreign service area and language program in the School of Foreign Service. Here, they are listening to French general Henri Giraud. (GU.)

In 1948, Gen. Douglas MacArthur (left), a five-star general and chief of staff of the US Army, walks with Fr. Edmund Walsh, SJ, founder of the Georgetown University School of Foreign Service. Father Walsh traveled to Tokyo, Japan, after serving as a consultant for the international military court in Nuremberg, Germany. (GU & Signal Corps US Army.)

After the death of Archbishop Michael Curley, there was a need for a new archbishop of Washington. Pictured here are Patrick Cardinal O'Boyle (left), Francis Cardinal Spellman, archbishop of New York (center), and auxiliary bishop William McDonald, rector of the Archdiocese of Washington, at O'Boyle's Episcopal consecration on January 14, 1948, by Cardinal Spellman. Patrick Cardinal O'Boyle became the archbishop of Washington from 1948 to 1973. (CUA.)

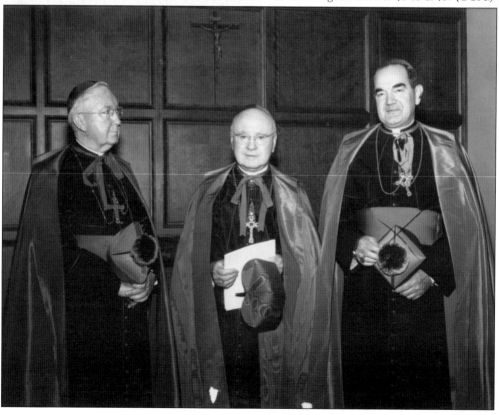

Fr. Vincent Capodanno, Servant of God, was a US Navy Catholic chaplain, and he received the Medal of Honor, Bronze Star, and Purple Heart for his actions in the Vietnam War. As a chaplain, Father Capodanno went among the wounded and the dying, administering the last rites to US Marines. He was killed after he heroically helped give the last rites to a soldier while he was seriously wounded himself, just yards from enemy lines. In May 19, 2002, Capodanno's cause was up for canonization. A ship was named after him called the USS *Capodanno* and given a papal blessing from Pope John Paul II in 1981. A wonderful book called *Grunt Padre* by Fr. Daniel L. Mode was written about his courageous life. (Both, AMSUSA, Archivist Taylor Henry.)

First Lady Rosalynn Carter celebrates Christmas at the White House with Fr. Gilbert Hartke and Catholic University of America students. They are celebrating the USO and the brave soldiers overseas. The first lady had met her future husband, Pres. Jimmy Carter, while he was a student at the US Naval Academy in Annapolis, Maryland, and she had been a supporter of the USO. Father Hartke was president of the USO at one time, a child actor, and a Notre Dame football player. He was best known founding the Department of Speech and Drama of Catholic University, and the Harke Theater has been named after him. (CUA.)

This 2003 photograph shows Msgr. William Devine at Holy Communion mass in Iraq for the Catholic US Marines. Rev. Devine served 22 years with the Navy and Marine Corps as a chaplain. In that time, he served three tours in Iraq as well as overseas assignments including many tours aboard Navy ships. (AMSUSA.)

Msgr. Jerome Sommer was 97 years of age when he died, the oldest chaplain of the Archdiocese for the Military Services in 2012. His classmate was Korean War hero Fr. Emil Kapaun, Servant of God. Sommer served as a hospital chaplain, an associate pastor, and a US Army chaplain for 29 years. Pope Benedict XVI numbered him among the Apostolic Protonotaries Supernumerary, the highest level among monsignors. (AMSUSA, Archivist Taylor Henry.)

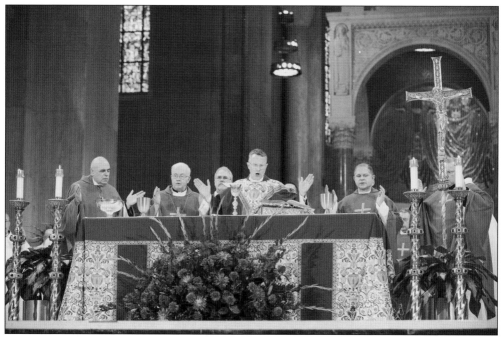

Archbishop Timothy Broglio serves mass with military chaplains at the Basilica of the National Shrine of Immaculate Conception in Washington, DC. The mass was dedicated for the Catholic servicemen who serve in the US Army, Air Force, Navy, Marine Corps, and Coast Guard. There are 1.8 million Catholics served by the chaplains. (AMSUSA, Archivist Taylor Henry.)

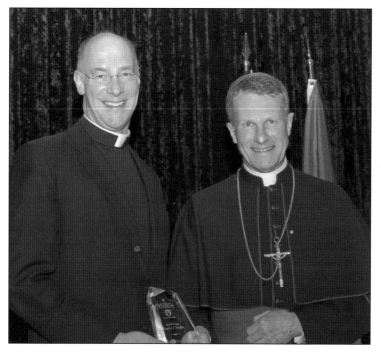

On the left, Msgr. Walter Rossi, rector of the Basilica of the National Shrine of the Immaculate Conception, smiles with honoree Archbishop Timothy Broglio, head of the Archdiocese for the Military Services, USA, at the embassy of Italy. The archbishop received an NMCAL award for his service to Catholic military and veterans. Monsignor Rossi escorted Pope Benedict XVI on a tour of the basilica in 2008. (NMCAL, Peter Stepanek.)

Mike Massimino (right), NASA astronaut and Columbia University mechanical engineering professor, is pictured here at the embassy of Italy with Patrick Cox, the 2009–2011 George Washington University Delta Tau Delta Gamma Eta Chapter president. Massimino serviced the Hubble Space Telescope during two missions, including an in-space repair. Massimino was honored and spoke about his Catholic faith when he looked out the window of the spacecraft; his family gave him rosaries, holy water, and pictures to take on his space trip. (NMCAL.)

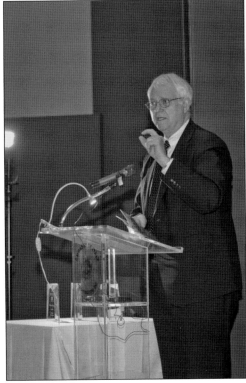

Dr. John Hamre's expertise is in security and defense. As the former Department of Defense comptroller in 1997 and deputy secretary of defense in 1999 under Pres. Bill Clinton, he is the CEO of one of the best think tanks in Washington, called the Center for Strategic and International Studies. In this photograph, Hamre reads a quote from the Bible as he is formally introducing Catholic honoree William Swanson, chairman of the board of Raytheon, at the embassy of Italy during a NMCAL gala. (NMCAL.)

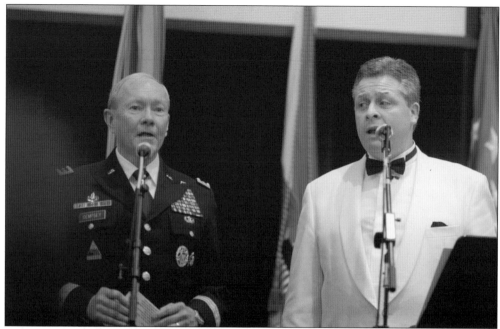

Gen. Martin Dempsey (left) sings "Isles of Hope, Isles of Tears" with Anthony Kearns. Dempsey, an Irish Catholic, attended John Burke Catholic High School in New York and the US Military Academy. Kearns is an Irish-born Catholic and a tenor; both gentlemen share a love of Irish music. (Kirsten Fedewa & Associates LLC.)

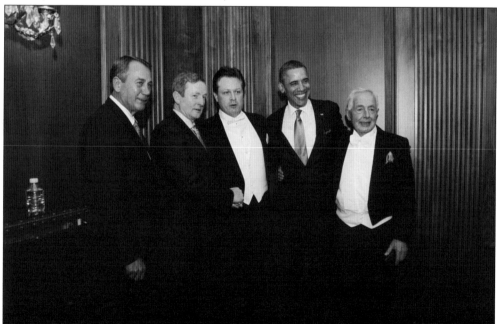

Pictured here, from left to right, are Speaker of the House John Boehner, Irish taoiseach Enda Kenny, Anthony Kearns, Pres. Barack Obama, and piano accompanist Patrick Healey at the 2013 Friends of Ireland lunch as Irish Catholics celebrate St. Patrick's Day at the White House. (Kirsten Fedewa & Associates LLC.)

Vice Pres. Hubert Humphrey shakes hands with students from CUA as Father Gilbert Hartke looks on at a visit in the White House in 1966. In the May 1960 West Virginia primary, Democratic presidential candidate John F. Kennedy won 60.8 percent of the vote to defeat Humphrey and went on to become the first Catholic president. Humphrey was sworn in as vice president in 1965, under Pres. Lyndon Johnson. (CUA.)

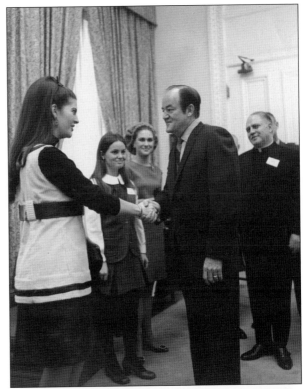

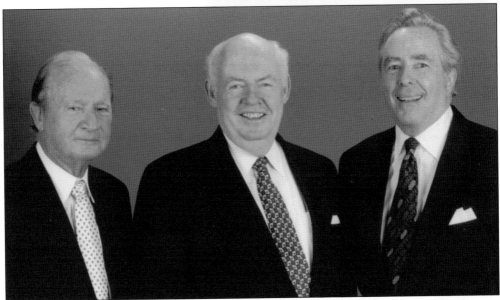

Three Catholic labor leaders pose in this photograph. They are, from left to right, John Bowers, head of the International Longshoremen's Union; Edward Malloy, Union leader of the Building Trade; and John Sweeney, former president of the AFL-CIO. Sweeney has been a mentor of the NMCAL Gala and a speaker at many of the organization's events. Malloy, former head of the Building Trade and Construction for New York, was honored with the NMCAL Legionary Award in 2012. (NMCAL.)

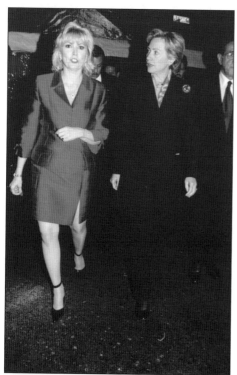

In 2001, Sen. Hillary Clinton (right) of New York pays a visit to East Harlem after a museum fundraiser to meet guests in an East Harlem restaurant. In 1994, Mother Teresa persuaded Clinton to open a home for orphaned children when they met at the National Prayer Breakfast. The former secretary of state could be a contender for president in 2016. (NMCAL.)

Former ambassador to the Holy See Raymond Flynn (right) is standing with his wife, Katherine Flynn. Flynn was a former mayor of Boston, Massachusetts, and is a pro-life activist. Also pictured is Rev. Anthony Pogorelc, SS, vice rector of the Theological College at the embassy of Italy. Raymond Flynn was honored with the NMCAL Lifetime Achievement Award. (NMCAL, Peter Stepanek.)

Two Catholic labor leaders, Sean McGarvey from the AFL-CIO (left) and Edward Smith, president of Ulicco Inc., smile at the NMCAL gala at the embassy of Italy. Smith was a former Lifetime Achievement recipient for NMCAL. (NMCAL, Peter Stepanek.)

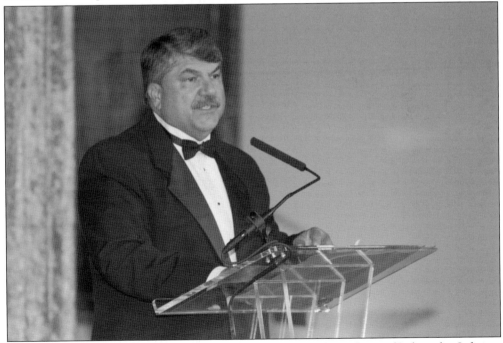

Richard Trumka, president of the AFL-CIO, was honored at the embassy of Italy with a Lifetime Achievement Award. His Polish and Italian roots come from the coal mines in Pennsylvania. Trumka's primary interest is to create jobs in America. (NMCAL, Peter Stepanek.)

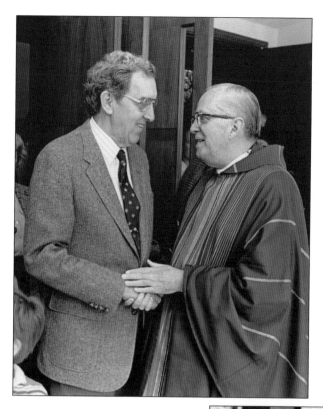

A former presidential candidate, US senator from Maine, and US secretary of state under President Carter, Edmund Muskie shakes hands with the pastor of Little Flower Parish after mass. (*Catholic Standard*, photograph by Michael Hoyt.)

Sen. Bob Dole and his wife, Elizabeth, pose in front of St. Joseph's Church on Capitol Hill in the late 1980s. He is the only person in the history of the two major political parties to have been a party's nominee for both president and vice president but never elected to office. Elizabeth was secretary of transportation under Pres. Ronald Reagan and secretary of labor under Pres. George W. Bush. (*Catholic Standard*, photograph by Michael Hoyt.)

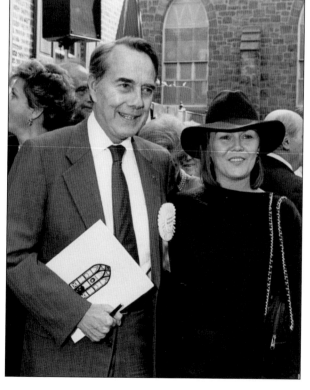

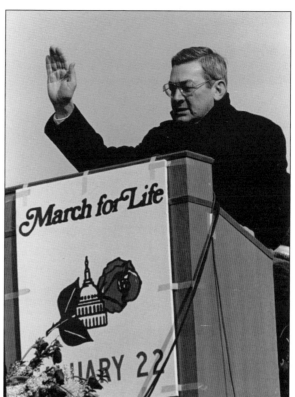

At right, Virgil Dechant, Supreme Knight of the Knights of Columbus, speaks at the March for Life on January 22. Below, protesters at the March for Life shake hands with Robert Bork, a pro-life supporter and judge of the US Court of Appeals for the District of Columbia. (Both, *Catholic Standard*, photographs by Michael Hoyt.)

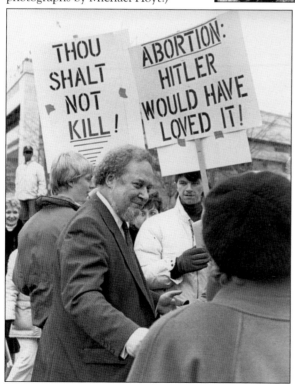

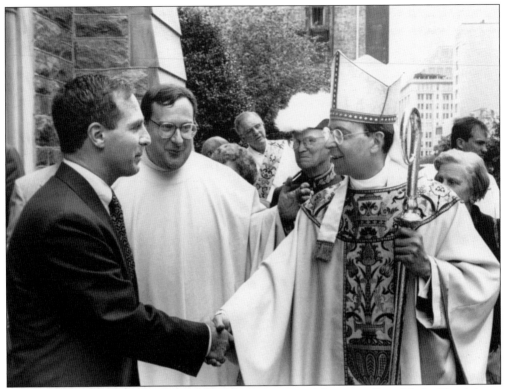

Monsignor Peter Vaghi Chaplain (center) of the John Carroll Society introduces Archbishop William Lori of Baltimore to FBI director Louis Freeh as they stand outside the Cathedral of St. Matthew the Apostle after the Red Mass. (*Catholic Standard*, photograph by Michael Hoyt.)

James Cardinal Hickey walks with Justice William Rehnquist. He served under Pres. Richard Nixon as assistant attorney general and served as chief justice during the presidencies of George H.W. Bush, Bill Clinton, and George W. Bush. (*Catholic Standard*, photograph by Michael Hoyt.)

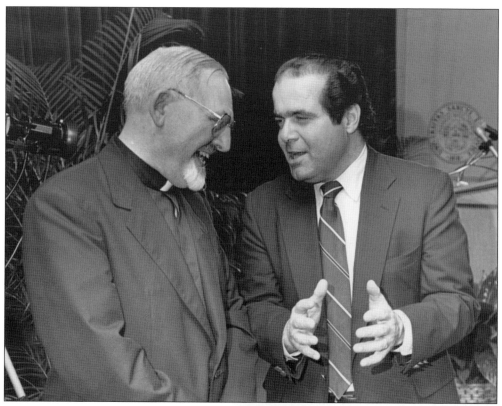

Justice Antonin Scalia stands with Fr. Peter Hans Kolvenbach, SJ, the Superior General of the Society of Jesus (Jesuits) from 1983 to 2008. The father resigned with the consent of Pope Benedict XVI. Scalia is an associate justice of the Supreme Court and is a devout Catholic, and his son Paul is a Catholic priest. (*Catholic Standard*, photograph by Michael Hoyt.)

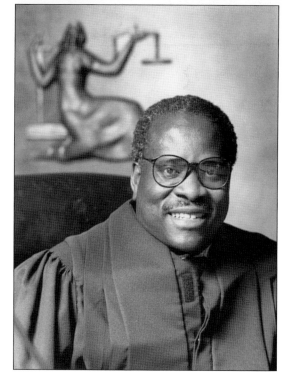

Justice Clarence Thomas is the second African American to serve on the Supreme Court and is an associate justice. Thomas was raised in Savannah, Georgia, by devout Catholic parents. He attended College of the Holy Cross and Yale Law School. At 16 years of age, he considered entering the priesthood, and he was the first black student to attend St. John Vianney's Minor Seminary. (*Catholic Standard*, photograph by Michael Hoyt.)

Pictured from left to right, Fr. Aidan Logan, US Air Force; Rev. Msgr. John Foster, vicar general; Archbishop Timothy Broglio of the Archdiocese for the Military Services USA; Amb. Raymond Flynn; Fr. Timothy Butler, US Air Force lieutenant colonel; former secretary of the veterans Jim Nicholson; and Fr. Captain Mike Parisi of the Chaplain Corps, US Navy stand together at an embassy of Italy dinner. (Sky High Art, photograph by Peter Stepanek.)

Ambassador to Italy Claudio Bisogniero (left) stands with Prince Lorenzo de Medici in front of a replica of Michelangelo's *Pieta* at the Third Annual NMCAL Roman Gala. Bisogniero and Medici host the annual event. (NMCAL, Peter Stepanek.)

NMCAL chairman Timothy Barton shakes hands with honoree Amb. Thomas Melady. In 1969, Pres. Richard Nixon appointed Melady ambassador to Burundi and later ambassador to Uganda in 1972. In 1989, Pres. George H.W. Bush appointed Melady Ambassador Extraordinary and Plenipotentiary of the United States to the Holy See. Ambassador Melady is honored here at the embassy of Italy for setting a path for the Vatican's recognition of Israel. (NMCAL, Peter Stepanek.)

In 2012, Miguel Diaz, American ambassador to the Holy See, theologian, and commentator from the University of Dayton, gives a keynote speech on the relationship between the Vatican and the United States at the embassy of Italy. Diaz was appointed to the office by Pres. Barack Obama and is the first Hispanic ambassador to the Holy See. (NMCAL, Peter Stepanek.)

At an NMCAL event at the embassy of Italy, lobbyist Thomas Boggs (left) is talking with Philippine ambassador Jose Cuisia. His father is former congressman Hale Boggs, and his mother, Lindy Boggs, served terms in Congress also. Ambassador Cuisia, a devout Catholic, is a winner of numerous awards, including a Lifetime Achievement of the Wharton Club in Washington, DC. (NMCAL, Peter Stepanek.)

James Mitchell was the US secretary of labor from 1953 to 1961 in the Eisenhower administration. Mitchell was a staunch advocate of labor; he encouraged management, created jobs, and was an eloquent spokesman on civil rights. The Catholic Church has provided a prominent role in the shaping of America's labor movement. It supported the economic well-being of workers and families— especially for Irish, Italian, and Slavic immigrants. (CUA.)

Frank Kendall III is speaking at the embassy of Italy at an NMCAL gala as he accepts the NMCAL Leadership Award. Kendall is a graduate of Georgetown Law School and has one of the most important jobs as the undersecretary of defense for acquisition, technology, and logistics at the Department of Defense. (NMCAL, Peter Stepanek.)

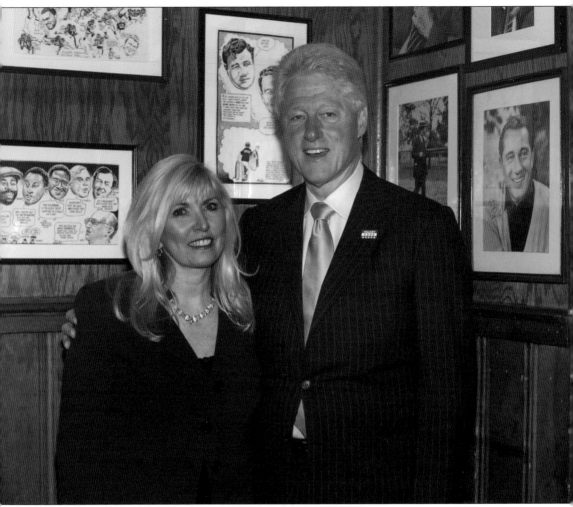

Pres. William J. Clinton stands with Christina Cox, NMCAL founder, at an Irish function. Cox had presented a bronze bust of Pope John Paul II at the White House to the former president to commemorate the pontiff's visit to Denver, Colorado, for the World Youth Day on August 12, 1993. (O'Dwyer & Bernstein.)

Six

PAPAL VISITS
IN WASHINGTON

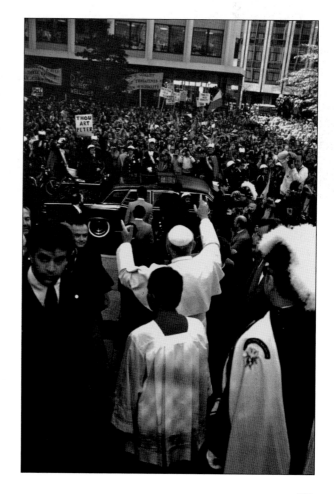

Karol Josef Wojtyla was
inaugurated Pope John Paul II
in 1978. One year later, he came
to visit Washington, DC. His
Holiness was also known as St.
John Paul the Great. In 1979,
Pope John Paul II turns to the
crowd at the footsteps of St.
Matthew's Cathedral. (Cathedral
of St. Matthew the Apostle,
photograph by Fred Maroon.)

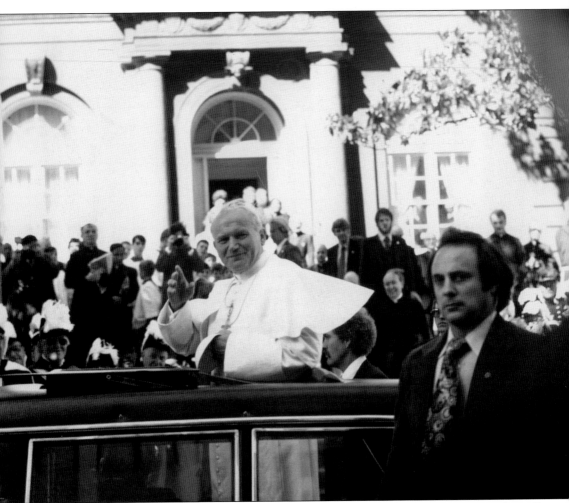

Pope St. John Paul II was known as the "Pilgrim Pope" and made 104 foreign trips, more than all previous popes combined. His Holiness consistently attracted large crowds on his travels. Here, he waves to the crowd along Rhode Island Avenue in front of the Cathedral of St. Matthew the Apostle. The pontiff was known to give many people a papal blessing as he rode by. (Photograph by Fred Maroon.)

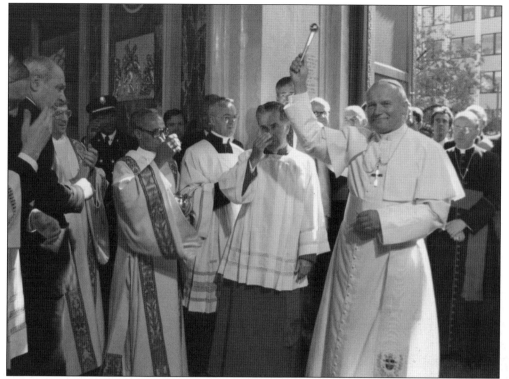

Pope John Paul II arrives at the front door of the Cathedral of St. Matthew and says mass for 1,500 priests. Cardinal William Baum, archbishop of Washington, hosted the pastoral visit and greeted His Holiness at the front entrance. Monsignor Jameson was chosen to coordinate the liturgies. (Photograph by Fred Maroon.)

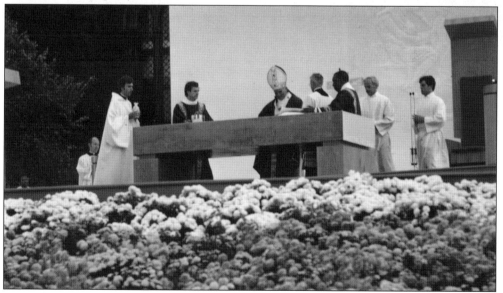

Pope John Paul II says an outdoor public mass on a windy day at the National Mall on October 7, 1979, for 175,000 people. Only 110 Catholic lay people and clergy were chosen to receive Holy Communion. (Photograph by Fred Maroon.)

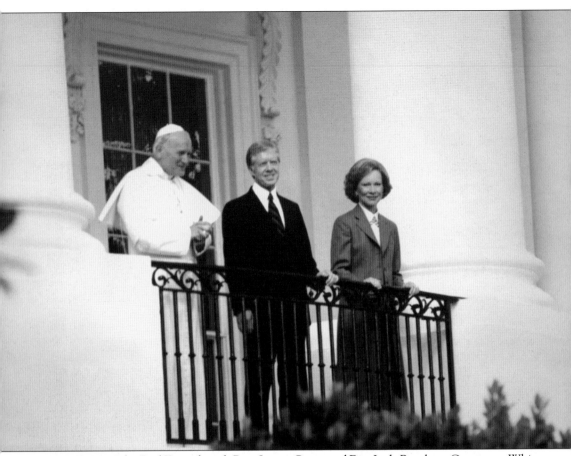

In 1979, Pope John Paul II stands with Pres. Jimmy Carter and First Lady Rosalynn Carter on a White House balcony. Pope St. John Paul was the first pope to visit the White House. (Fred Maroon.)

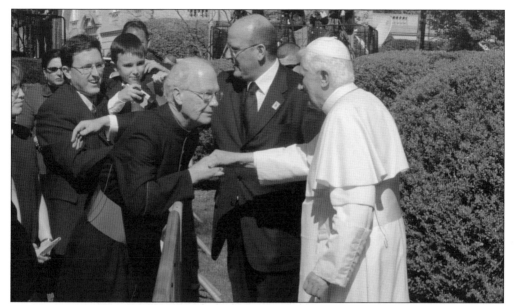

On April 16, 2008, Pope Benedict XVI arrives at the Church of the Annunciation at 3125 Thirty-ninth Street NW and is greeted by the pastor. His Holiness was also greeted by 130 schoolchildren who sang "Happy Birthday" to the Holy Father for his 81st birthday. (*Catholic Standard*, photograph by Michael Hoyt.)

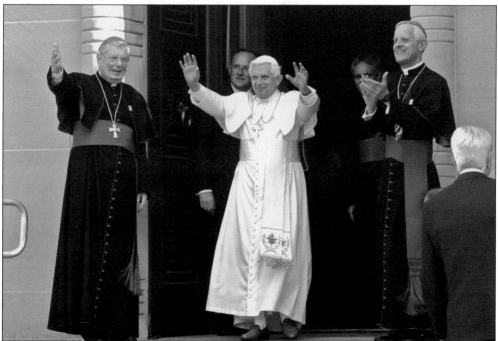

On April 15, 2008, Pope Benedicts XVI traveled on a pilgrimage to Washington, DC, and stayed at the Vatican embassy on Massachusetts Avenue. He was hosted by Archbishop Pietro Sambi (left) and Donald Cardinal Wuerl, archbishop of Washington, DC (right). His Holiness waves to a crowd of schoolchildren waiting on the lawn to greet him for his birthday. (*Catholic Standard*, photograph by Michael Hoyt.)

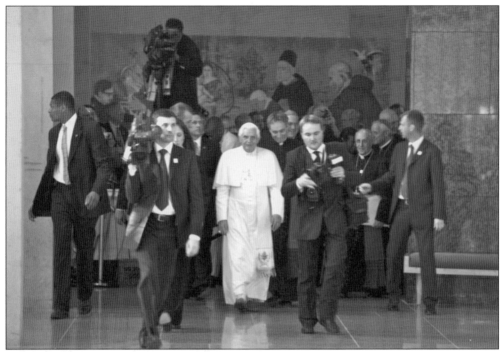

Pope Benedict XVI met Buddhist, Muslim, Hindu, and Jewish leaders and representatives of other interreligious communities at the Pope John Paul Shrine on April 17, 2008. (PJPII Shrine.)

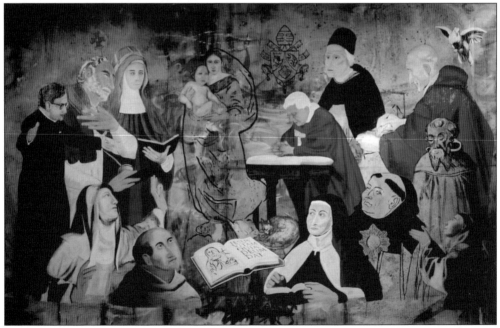

NMCAL commissioned artist Fred Villanueva to create this painting, called *Pope Benedict XVI in the Holy Theologians*. It was on loan to be exhibited at the Pope John Paul II National Shrine on April 16, 2008, for the visit of Pope Benedict XVI. (NMCAL.)

Pope Benedict XVI announced his resignation and retirement on February 28, 2013, and Jorge Mario Bergolio became Pope Francis (pictured) on March 13, 2013. The first Jesuit pope chose the papal name Francis in honor of St. Francis of Assisi. This is an oil painting created by Luis Peralta Del Valle, an American who was born in Nicaragua and won the National Artist award at a NMCAL gala. (Luis Peralta, NMCAL.)

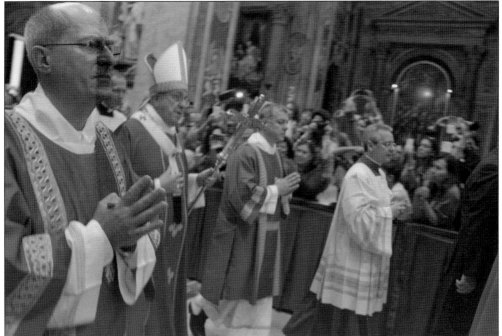

Pres. Barack Obama made an official visit to Vatican City to see Pope Francis on March 27, 2014. His Holiness was invited by House Speaker John Boehner to be the first pope to address Congress, on September 24, 2015. Thirty-one percent of the members of Congress are Catholic. Pope Francis will meet President Obama during an official visit to the White House. (NMCAL.)

DISCOVER THOUSANDS OF LOCAL HISTORY BOOKS FEATURING MILLIONS OF VINTAGE IMAGES

Arcadia Publishing, the leading local history publisher in the United States, is committed to making history accessible and meaningful through publishing books that celebrate and preserve the heritage of America's people and places.

Find more books like this at
www.arcadiapublishing.com

Search for your hometown history, your old stomping grounds, and even your favorite sports team.

Consistent with our mission to preserve history on a local level, this book was printed in South Carolina on American-made paper and manufactured entirely in the United States. Products carrying the accredited Forest Stewardship Council (FSC) label are printed on 100 percent FSC-certified paper.

MADE IN THE USA